IMAGES
of America

PORT WASHINGTON

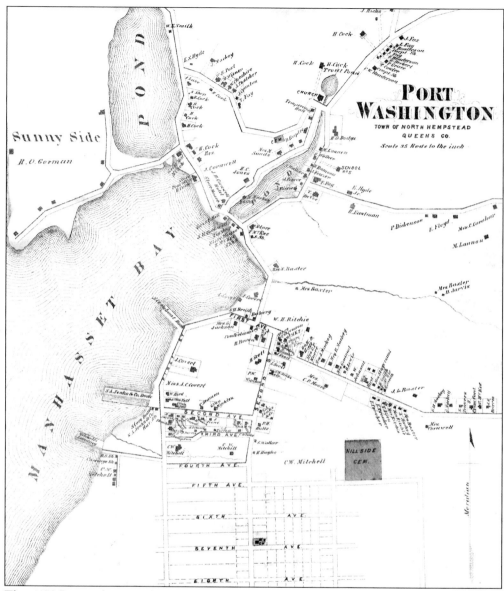

This 1873 Beers atlas page shows the wide-open spaces that characterized the southern part of Port Washington before the arrival of the Long Island Rail Road in 1898. The large tracts of land owned by the Baxters, Mitchells, Cornwells, Cockses, and others were subsequently developed into dense housing. They became the home base for suburban commuters who depended on New York City for their livelihoods. In the early 1900s, First Avenue became Main Street, and Fourth, Fifth, Sixth, Seventh, and Eighth Avenues were renamed for developers and prominent residents. (Courtesy of the Port Washington Public Library.)

On the cover: Please see page 17. (Courtesy of the Port Washington Public Library.)

IMAGES
of America

PORT WASHINGTON

Elly Shodell
and the Port Washington Public Library

ARCADIA
PUBLISHING

Published by Arcadia Publishing
Charleston, South Carolina

Printed in the United States of America

Library of Congress Control Number: 2008942675

For all general information contact Arcadia Publishing at:
Telephone 843-853-2070
Fax 843-853-0044
E-mail sales@arcadiapublishing.com
For customer service and orders:
Toll-Free 1-888-313-2665

Visit us on the Internet at www.arcadiapublishing.com

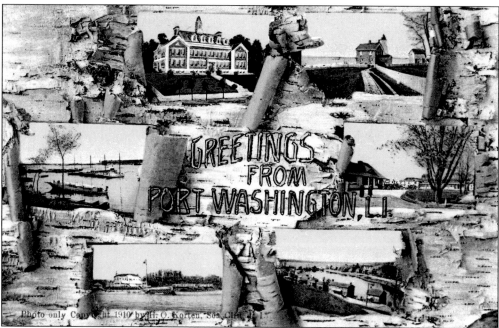

Welcome to Port Washington! Produced in 1910, this tourist postcard provides a bird's-eye view of Main Street School, the lighthouse, the Mill Pond, the Long Island Rail Road train station, and Manhasset Bay. To those who care about the past and are dedicated to the future, these are reminders of the landmark structures and natural surroundings that make Port Washington unique.

CONTENTS

ACKNOWLEDGMENTS

Port Washington is the result of decades of collecting, archiving, and protecting the invaluable photographs and memorabilia donated to the Port Washington Public Library by generous members of the community. For this, I thank the library for taking so seriously its task of passing on vital documents and spoken memories from generation to generation. Library director Nancy Curtin, the board of trustees, and the library foundation have supported local history over the years and provided safe haven for the photographs, maps, and images that are included.

This book of around 250 photographs was selected from a collection of over 30,000. The process of choosing visuals would have been impossible without the trained eyes, methodical attention, and extraordinary insights of Janet Schneider and Francesca Pitaro. Their dedication and detailed knowledge inform every page of this volume. For refining the process even further and shaping the final product, I would like to acknowledge the professional skills and generous time contributed by Janet West, director of information services at the Port Washington Public Library, and Liisa Sclare, author and architect. Robert Bracken used his experience as a school administrator and teacher to research and provide information, digging deep and often in the archival stacks. His boundless energy and training in organizing and interpreting primary source materials helped bring this work to life. Dr. George Williams, Joan Kent, Virginia Marshall Martus, Priscilla Ciccariello, Debbie Greco, Elizabeth Young, Alan Dinn, Frank Pavlak, Peter Zwerlein, and Richard Whittemore (who passed away in 1999) have all experienced the joys of putting together the pieces of Port's past. We have drawn on their collective insights and wisdom. Special thanks go to our editor at Arcadia Publishing, Rebekah Collinsworth, whose enthusiasm helped us realize we had a product worth pursuing and whose patient guiding hand ensured smooth sailing and clear text.

To my husband Mike and the family we raised in Port Washington, Matt and Dan, their wives Ellen and Teena, and now their children, Andy, Jeremy, and Saheli, I hope this book will inspire and teach and provide a link to the past in the years ahead.

Unless otherwise noted, all images are courtesy of the Port Washington Public Library.

INTRODUCTION

This volume, *Port Washington*, presents a photographic history chronicling the rise of this picturesque town located on the North Shore of Long Island. It traces its evolution from a small clamming and fishing community in the 1890s to the bustling commuter haven that it is today.

Always linked to New York City, both by its proximity (17 miles) and direct water routes, Port Washington is a case study in suburbanization. One of Long Island's oldest settlements, it was originally inhabited by the Algonquin Indians' Matinecock tribe, who called it Sint Sink, or "Place of Stones." It was later used a base for fishing before the Europeans arrived in the 1600s. In early Colonial times through the Revolutionary War, early Dutch and English settlers knew the area as Cow Bay. Among the first families in the 17th and 18th centuries were the Sands and Dodges, who came to Port Washington from Block Island; the Cornwalls from Southampton; and the Baxters from Flushing. Other early settlers were the Motts, Hegemans, Onderdonks, Mitchells, Monforts, and Hewletts. Farms and grazing land, blacksmith and wheelwright shops, and woolen mills and gristmills produced the necessities of life.

Over the next two centuries the peninsula, surrounded by Long Island Sound, Manhasset Bay, and Hempstead Harbor, became a center for shellfishing, shipbuilding, sand mining, early aviation, and service work on the big estates. As late as 1890, there were only about 1,000 inhabitants in Port Washington. But by 1898, immigrants arrived along with the Long Island Rail Road, a library was founded, schools opened, and manufacturing and small industry took root. Villages began to incorporate, politicians and real estate were born, and the "modern" Port Washington began to take shape. It currently is part of the town of North Hempstead and encompasses 32 miles of shorefront, four villages (Baxter Estates, Port Washington North, Manorhaven, and Sands Point), a large unincorporated area, and part of another village, Flower Hill, which straddles Port Washington and Manhasset.

Changes in the region were witnessed and experienced over the decades by several prominent local amateur and professional photographers such as Stanley Gerard Mason, Ernie Simon, William Leiber, Robert Fraser, and Monte Marshall. Through their lenses they captured the drama and reality of the times they lived in, mostly the 1890s to the 1960s. Their negatives and prints are protected and saved for posterity at the Port Washington Public Library, founded more than 100 years ago and home to 30,000 images, 20,000 negatives, and 3,000 slides. This immense collection portrays people, places, and events that may have never made it into the official histories of the times or the standard newspaper or magazine outlets. In the pages that follow, baymen whose lives revolved around the waters are depicted in their homes, working the fishing lines, hauling the boats, and gathering at the town dock. Yachtsmen are portrayed racing

powerboats, competing for trophies, and sharing a social and recreational camaraderie. Members of the African American community, which dates back six generations, come to life as they pose for the camera on graduation day or come back from the war. Early aviators and their planes are captured as they barnstorm or hobnob with the rich and famous funders who lived in Sands Point and helped the aeronautical industry grow. Italian sand miners share traditions of work, family, song, games, and food. These are some of the people who have made Port Washington the rich mix of ethnicities, income levels, and ages that it is today.

For those readers who are new to the community, this book provides some of the "hidden" backstory of Port Washington. Old photographs provide a context and location for structures like the Hearst estate, demolished years ago, or the Sands Point Bath and Racquet Club, which burned to the ground. Amateur photographers, often anonymous, benefitted from the newly invented celluloid roll film that replaced more cumbersome tintypes and daguerreotypes. They provide the only record of disappeared streets, schools, streets, and trolley tracks, the once-lively Pan Am air terminal, sand mining trestles, boatyards long gone, businesses and homes lost to neglect or calamities, and clam and oyster shacks that have been torn down to make way for housing. These individual photographs are revealing in their details, as are the family albums that have been saved for posterity and are also represented in the book. The Fraser family in the late 1800s and early 1900s, for example, kept immaculately captioned and dated photographs recording the surroundings of their Ashcombe estate in Sands Point. Although the ponds have since dried up and the property has been subdivided, the albums evoke an era of stability, comfort, and privacy. Workers on the William Bourke Cockran estate in the 1920s took pictures of each other at ceremonies and on the grounds and outbuildings, which included the vast acreage of the current Harbor Acres and St. Peter's Church. In the 1940s and 1950s, sand miners made sure to bring their cameras to Sardinian family festivals, annual holiday parties, and bocce games. This is preservation of the highest order.

Photographs in the book also refer to some of the wealthiest families in America. Attractive because of its idyllic location on the bluffs that surround Long Island Sound and its easy commute to New York City offices, Port Washington in the 1920s was home to the Guggenheims, Belmonts, Astors, Goulds, Hearsts, Pratts, Whitneys, Luckenbachs, Holmes, Fleischmanns, and developer Carl G. Fisher. Beyond the limit of its modest five square miles, Port Washington gained fame nationally and internationally. It is the "East Egg" of F. Scott Fitzgerald's masterpiece *The Great Gatsby*. Charles Lindbergh wrote *We* in the Guggenheim estate in Sands Point. "Typhoid Mary" Mallon was a kitchen maid in Sands Point. The first flying boats to Europe took off from Port Washington in the 1930s. And Cow Bay sand made the concrete that went into the subways, skyscrapers, and sidewalks of New York City. Literary giants, political activists, and performing artists all shared the zip code 11050. At one time it was home to suffragettes Harriet Laidlaw and Alva Vanderbilt Belmont, Ambassador Averill Harriman, United States representative William Bourke Cockran, Congressman Frederick C. Hicks, Perry Como, Maureen O'Hara, Sinclair Lewis, the Benets, Fontaine Fox, John Philip Sousa, Alicia Patterson, William Lippincott, and M. Lincoln Schuster—to name just a few. Many of Port's original structures and landmarks, both on land and water, still stand despite their years and will be recognized and recognizable in the book. They endure because of the efforts of local citizens to save and give priority to their history. With this book, we hope to build on that foundation.

One

COMMUNITY SPIRIT

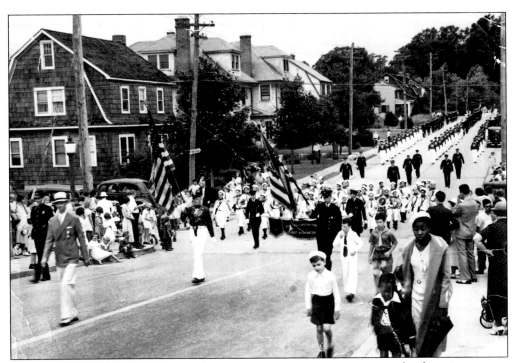

One indication of Port Washington's community spirit is its many parades featuring events, clubs, and organizations, some dating back 100 years or more. Whether for charitable, political, educational, sports, or social purposes, the bonds of community shine through. In this July 1935 parade of more than 4,000 Nassau County firemen, Port Washington news editor Ernie Simon is grand marshal, seen on the left in the white hat.

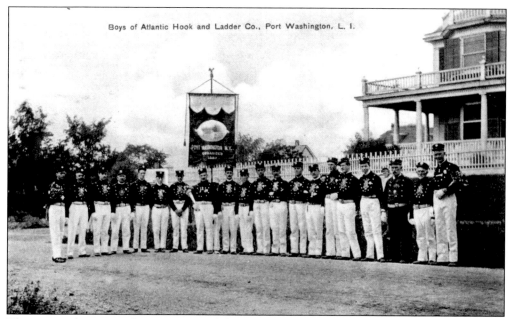

Boys of Atlantic Hook and Ladder Co., Port Washington, L. I.

This postcard captures the precision and fine presentation of "The Boys" of the Atlantic Hook and Ladder Company. Founded in 1886 by 26 volunteer firefighters, the Atlantics were organized by Charles Baxter. The original meeting was held at McKee's store on Shore Road, at a time when the village had 1,000 residents. The hope was to replace the existing bucket brigade with a more efficient fire protection system.

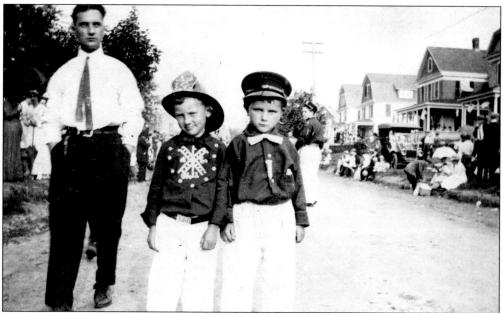

Port Washington's pride in its fire department, medics, and police department is evident in the everyday life of the community. From their earliest days, young boys aspired to wear the uniform of the volunteer companies. Little Willie Leiber, on the left, stands on Main Street with his friend Russell Hults in August 1912, emulating their family members who were members of the Atlantic Hook and Ladder Company.

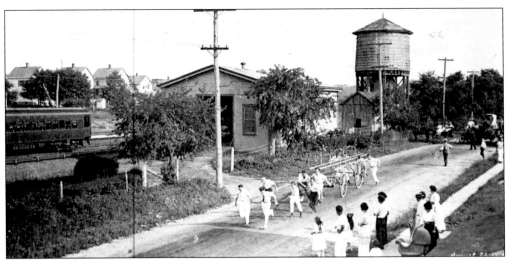

The railroad tracks and property facing Haven Avenue looked like this in 1914. There was a pump house and water tank for refilling the steam engines and a barn for the horses and wagons of the railway express service. In the foreground are members of the Flower Hill Hose Company participating in a parade and contest with the Atlantic Hook and Ladder Company. Note how they pulled their trucks and ladders to answer alarms.

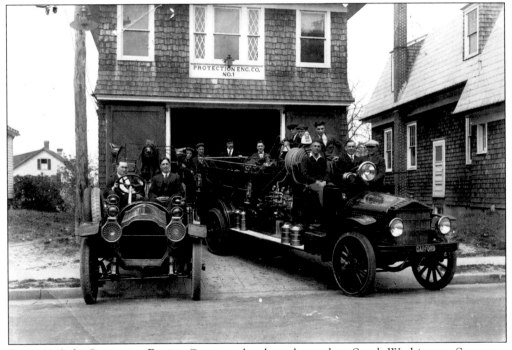

Since 1910 the Protection Engine Company has been located on South Washington Street, on a plot of land bought for $600 in 1906 with later additions by contractor Eugene E. Carpenter. Posing in front of the building are firefighters not in uniform. Their newly purchased Garford engine pumped 350 gallons per minute and contained a new chemical soda and acid system to help fight fires.

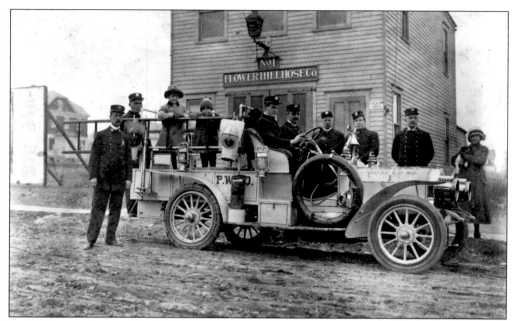

In 1905, responding to the need for additional protection in a growing community, the Flower Hill Hose Company was founded by Chief Frederick Snow. It followed the local Atlantic Hook and Ladder Company (founded in 1886) and Protection Engine Company (founded in 1892). It was named for its location on Flower Hill Avenue, and this picture may have been taken at the first open house in February 1909.

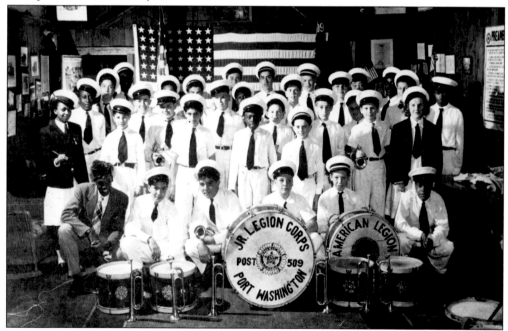

The Port Washington American Legion post was formed in 1919 to offer relief to comrades in distress returning from war. It supplied legal aid, flood relief, mortgages, a home-going fund, and a Christmas fund to servicemen after World War I. As the group grew and flourished, it attracted youngsters into its Junior Legion Corps, seen here in the 1940s.

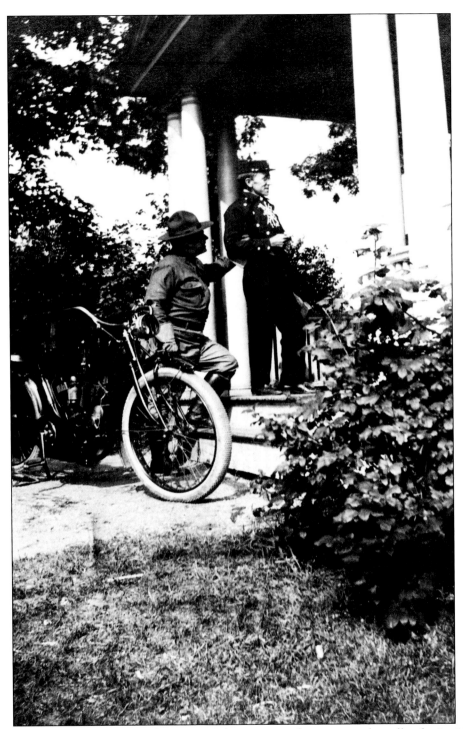

Atlantic Hook and Ladder member Burges Johnson, in uniform, awaits the call as he is visited by a motorcycling friend at his home, Borealis, around 1906. Johnson, a well-known author and humorist, was also active in the Progressive Party. He recalled using hand-drawn vehicles to pull the hose carts and the ladder truck, sometimes requiring a long jaunt to outlying districts.

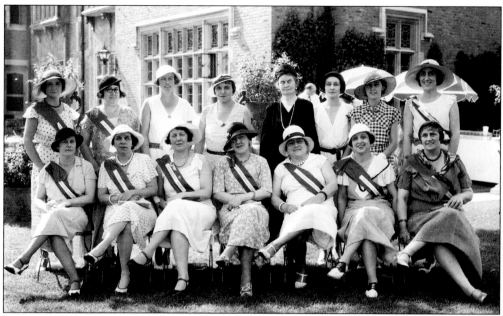

Bettie Holmes (in black), wife of Christian R. Holmes of Sands Point, was the sister of Julius Fleischmann. She hosted garden parties at her home the Chimneys throughout the 1920s and 1930s to raise money for charitable causes in Port Washington. One of her pet projects was building a new high school stadium in 1932 to provide jobs in the face of the Depression. She is seen here with winners of prizes sponsored by the Arboretum for Botanical Preservation.

Republican committeewomen look at the camera and pose for a photograph during a break in one of their regular home meetings in the 1930s. Second from left in the first row is Alice Lynch, wife of Jim Lynch. Fourth from the right is Genesta Strong, president of the Nassau County Federation of Republican Women.

Card parties and participation in parades and celebrations were some of the activities of the Daughters of the American Revolution. Granted a charter for the Darling Whitney Chapter of Port Washington on April 23, 1938, five members take time to pose for a picture as they celebrate the second anniversary of the "sisters" in style at the home of Edward and Mary West on Davis Road in March 1940.

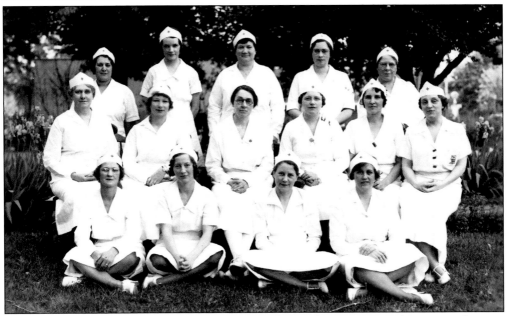

Port Washington women in the 1940s were trained in Red Cross nursing by registered nurses from the Village Welfare Society. The society also sponsored canning kitchens and sewing rooms. Members helped out in flood disasters and prenatal and childbirth care. They conducted tonsil clinics, provided doctors and dentists, and supplied families with new and used garments and thousands of quarts of milk for their children.

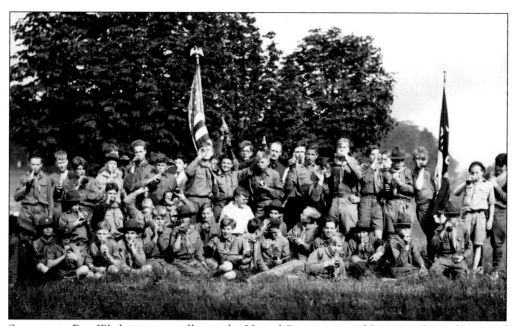

Scouting in Port Washington, as all over the United States, engaged large numbers of boys and girls in hiking, doing good deeds like neighborhood cleanups, studying nature, and learning crafts. One of Port's weekly magazines in the second decade of the 20th century was *Plain Talk*, which regularly featured a column on the Boy Scouts. This is a picture of Troop No. 7 in 1929 enjoying a picnic at Lion's Field.

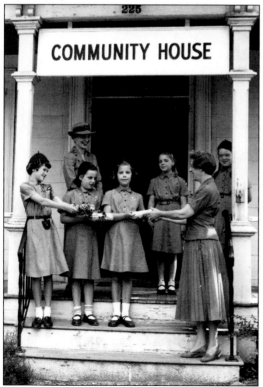

The spirit of volunteerism and commitment continues in Port Washington. Residents for a More Beautiful Port Washington, the League of Women Voters, Community Chest, Landmark, civic associations, Parent-Teacher Associations, fraternal organizations, child and youth services, Littig House Community Center, Community Action Council, and the chamber of commerce all contribute to the betterment of the community. The Girl Scouts, seen here in 1955 in front of 225 Main Street, carry on the gift-giving traditions of the past.

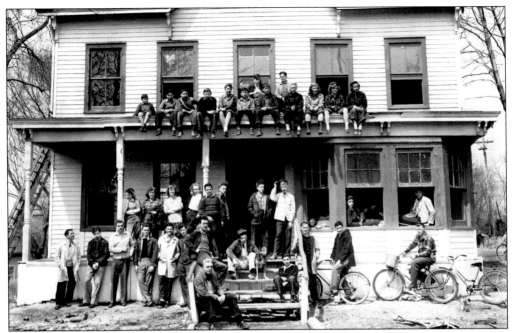

These teenage boys and girls are members of the construction crew of the Port Washington Youth Center. Sponsored by the Port Washington War Council Civilian Mobilization Unit with additional contributions from local businesses, the restored and painted house was opened on May 6, 1944, to provide after-school and weekend activities for 300 boys and girls.

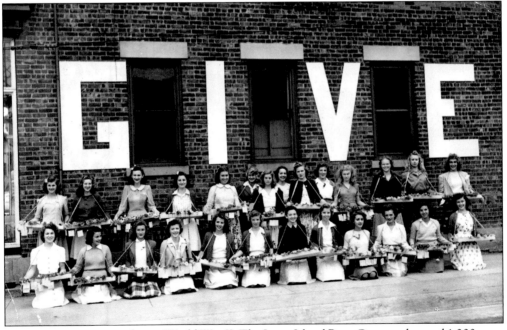

Community spirit grew during World War II. The Long Island Rose Growers donated 1,000 roses to Port Washington's defense fund in October 1942. Florist S. F. Falconer prepared them, and high school girls displayed them. The roses sold like hotcakes. Quarters clinked in cartons. At the end of the day, $20,000 had been raised for the war effort.

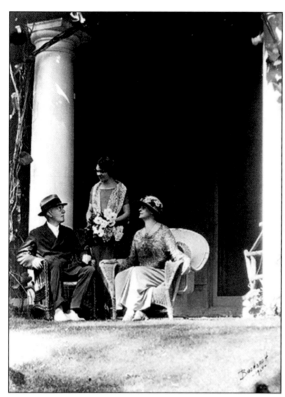

Harriet Burton Laidlaw (1873–1949) was active in the early days of the League for Women's Suffrage. She is seen here in the early 1920s with her husband, James, and her daughter, poet Louise Burton Laidlaw. They hosted many fund-raisers for the cause at their elegant home in Sands Point. Harriet also devoted her energies to the movement for international peace.

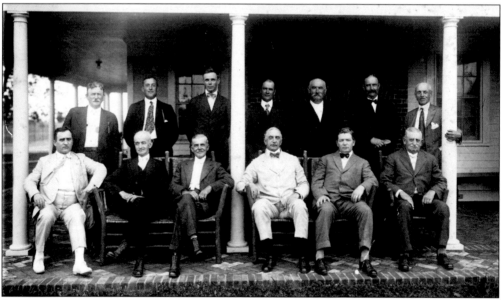

Involvement in civic projects has taken many forms in Port Washington and continues to be a time-honored expression of commitment to the Cow Neck peninsula. Here North Hempstead Town Board members and water commissioners of Westbury and Carle Place gather at the Westbury Gardens Inn on July 13, 1916. They were attending a dinner given by W. G. Fritz. Included are the board's attorney, Judge Dodge, Judge Cornelius Remsen, supervisor Philip Christ, and Thomas O'Connell.

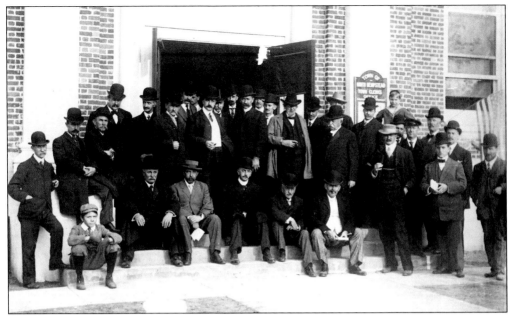

To celebrate the opening day of the North Hempstead Town Hall in Manhasset, employees and elected officials gather outside their headquarters on September 7, 1907. Designed by Frank T. Cornell, the building's construction began in 1905, and it still houses the supervisor's office. Positions in the town, such as supervisor and councilman, have historically led to higher responsibilities in both Nassau County and New York State.

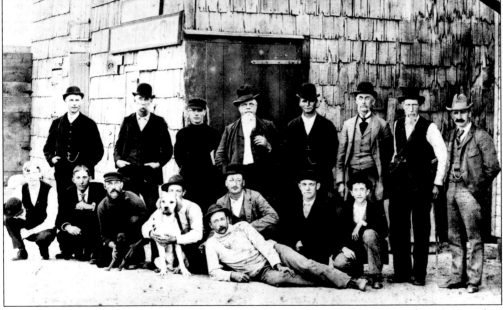

These baymen seem clearly determined as they meet at the Old Red Mill around 1900. Here they forged political alliances, swapped stories, and talked about business. They "discussed matters of state and the state of matters." Harold L. Seaman identified some of the men: Gus Smith, Charlie Rogers, Ed Hyde, Jake Cocks, James Smith, Richard Foster, Chris Fay, Charlie Hyde, Arthur Foster, Dan Hyde, Howard Smith, Ike Smith, George Lewis, and Nete Mackey.

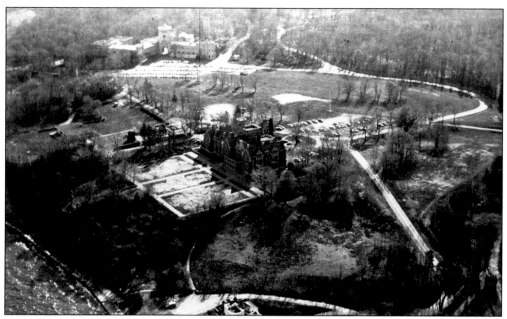

The 162-acre Guggenheim estate played a vital role in World War II. In 1946, its 70 rooms were used by 700 employees of the U.S. Navy. Locally more than 2,000 citizens joined the auxiliary police, reserve firemen, air raid wardens, and decontamination corps. A local paper exulted that this was "one of the finest examples of Democracy at work that has ever been exhibited by the American people."

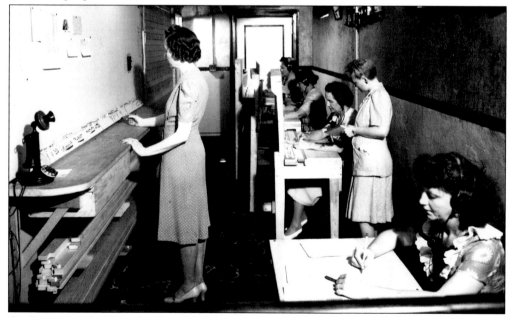

On December 8, 1941, the Port Washington War Council was formed, headed by Robert F. Gregory. Thousands of local residents participated by buying war bonds, driving ambulances and trucks, helping soldiers at USO hospitals, staffing evacuation hospitals, defending the coastline, and filling jobs left vacant by enlisted soldiers. Here women volunteers pitch in at the Port Washington Communications Center located at the Guggenheim estate.

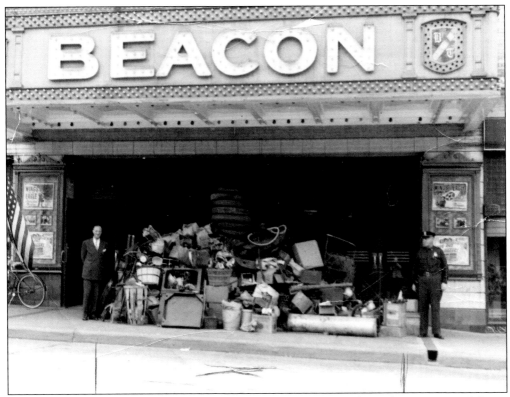

The Beacon Theater on Main Street was used as a donation point for civilian scrap metal drives during World War II. The theater was and still is located at 116 Main Street and was opened in 1927 with over 1,600 seats and a pipe organ. This photograph was taken by Mason Studios in 1942.

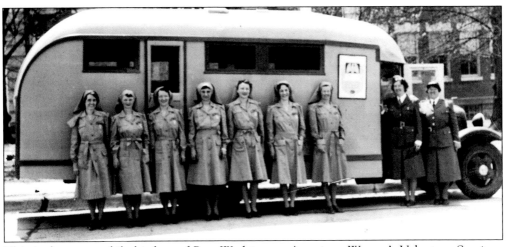

This is the new mobile kitchen of Port Washington American Women's Voluntary Services, on May 8, 1942. As part of the mobile transport unit, it worked in cooperation with the Village Welfare Society in transporting patients to clinics and hospitals during World War II. Entertainers were brought to and from army posts and hospitals in these vehicles.

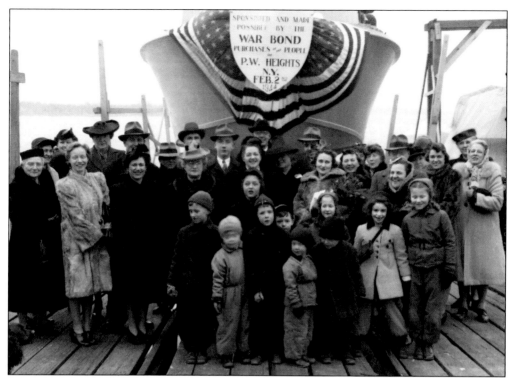

Raising money for World War II inspired patriotism in Port Washington's prominent citizens. Eight war loan drives raised an astounding $20 million. This launching of a PT boat at the Purdy Boat Yard on February 2, 1944, was one of the efforts supported by the war bonds. Residents Herbert Bayard Swope, Bernard Baruch, Harry Guggenheim, and the Baron Robert de Rothschild also volunteered as chauffeurs, air raid wardens, and traffic brigade leaders.

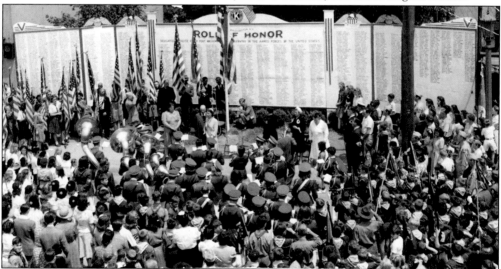

By 1945, it was calculated that around 1,600 local residents had served in the armed forces. Of that number, 40 had perished, and their names were inscribed with gold stars on a special honor roll. On May 30, 1944, an impressive crowd turned out to a ceremony honoring Port's citizens serving in the armed forces.

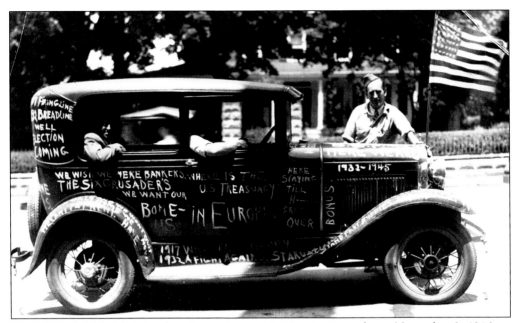

The placarded Model A in this picture is participating in a parade on November 2, 1946, to secure rental housing for 120 homeless veterans and their families. The "Bonus Army" refers to a 1932 effort to support men and women returning from war. Photographer Stanley Gerard Mason captured the action across the street from the Beacon Theater on Main Street. The parade was led by the fire department and the high school band.

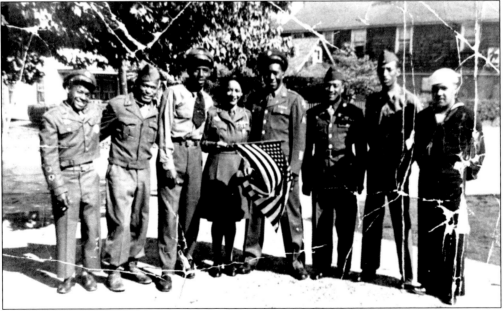

As this picture reflects, the historic Biddle family was proud of its participation in the fighting forces during World War II. In a snapshot taken near Harbor Road in Port Washington, family members have returned home: (from left to right) Harold Tyson, Lorenzo Loze, Walter Biddle, cousin Evelyn "Niecey" Loze, Frank Miller, Lawrence "Buddy" Dumpson, Harry Townsend, and Francis Eato.

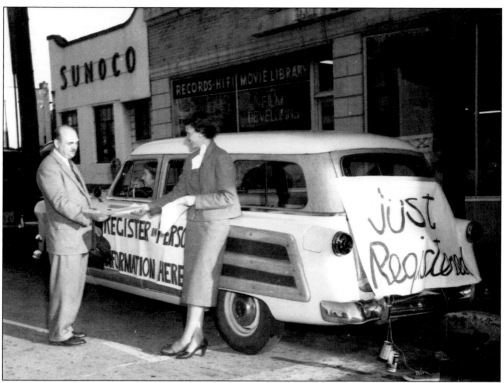

Continuing a tradition of political activism, Dorothy Donovan of the Port Washington League of Women Voters collects voter registration forms on Main Street in 1960. The league's local branch was organized in 1956 to teach women how to register and vote. The station wagon was dressed up in wedding garb as a way of getting potential voters' attention.

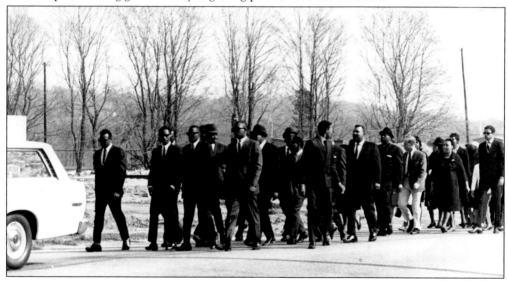

After civil rights leader Martin Luther King Jr. was shot in Memphis on April 4, 1958, race riots erupted around the country. In Port Washington, marchers paid their respects on April 7, 1968, accompanied by the Soul Brothers band. In 1968, Martin Luther King Jr. Day was established as a United States national holiday.

Two

FAMILY LIFE

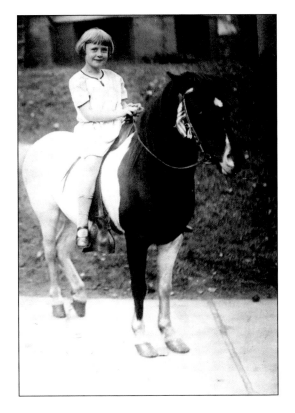

Six-year-old Alice Cornwell, seen here riding her pony in August 1922, was a member of one of Port Washington's founding families. Horseback riding was a favorite leisure activity for the children of Sands Point, where the Cornwells settled. With roots dating back to 1776, one of her ancestors was an original signer of the declaration of support of the Continental Congress in 1776.

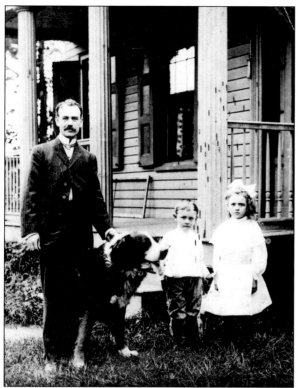

A prominent Port Washington family in the early 1900s was the Olandts. William H. Olandt was a local purveyor of eggs and butter. He moved his family to Port Washington from their farm on Queens Boulevard around 1906. This family pose reveals two serious children standing somewhat at attention while the large family dog is firmly in the grasp of William H. Olandt, who clearly controls the household and pets.

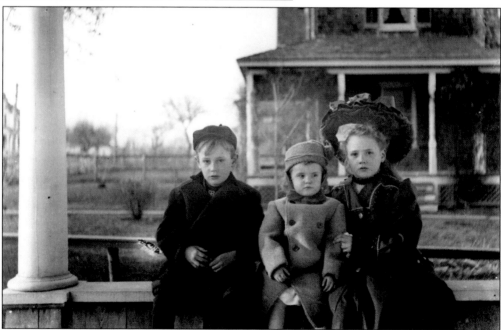

Helen Olandt, on the right in this picture on the porch, was born in 1902 and died in 1992. She is seen in her winter bonnet with her two brothers at their house at 19 North Maryland Avenue. Helen attended Flower Hill School and later Main Street, where she was valedictorian. In the background is Elizabeth Brown's house, around 1910.

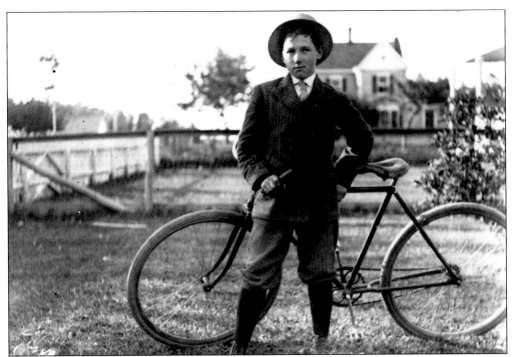

The Olandt family boys prized their bicycles and used them both for transportation and pleasure riding in the second decade of the 20th century. In its original form as a glass plate negative, the Olandt photographs are crisp and clean and have survived over the decades to tell something about the clothing, tastes, and respectability of upper-middle-class families at the time. Bicycling enthusiasts will notice the pristine condition of this classic two-wheeler.

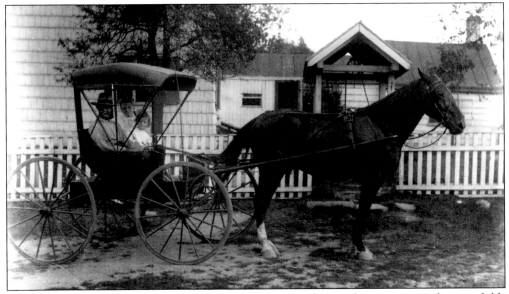

Buggy rides were a common way for families to get around Port when it was mostly open fields and pastureland surrounded by farms and orchards. The lack of asphalt roads made for a bumpy ride, but the Olandt family, with young Karen seated with her mother, seems to be a happy threesome in this 1907 scene on North Washington Street.

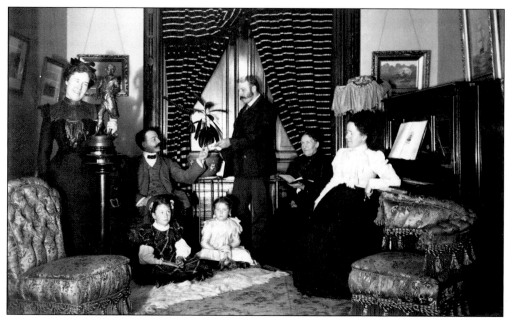

The Wicks family built its home in Port Washington Heights around 1898. Helen Wicks Reid (child holding mask) was the daughter of John Van Pelt Wicks, a Brooklyn dentist who invested in the first home site development in Port Washington when the Long Island Rail Road reached Port in 1898. The residence was located at the intersection of Bayview and Carlton Avenues. Helen later ran a dance studio from there and founded the Players Club.

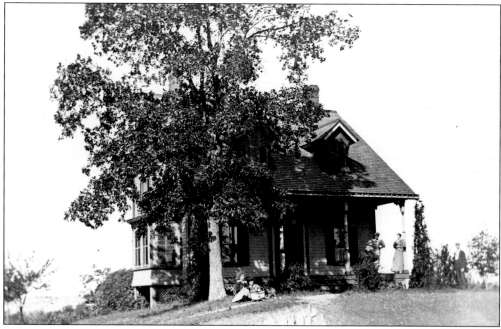

In later years occupied by Helen Wicks and her husband William Reid, the Wicks home was a typical 1890s residence. Similar homes in what was called Port Washington Heights appealed to New York City theatrical personalities Sallie Fisher, Fritz Williams, Al Holbrook, and Billy Newman, who built the Nassau Theater, Port Washington's first movie house, in 1914.

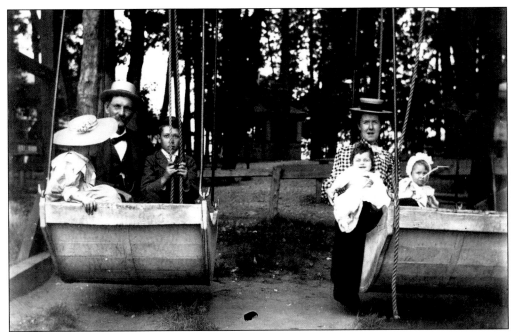

Sitting on swings that may have been made from barrels, Reid family members are formally dressed in straw hats and bonnets, as was the custom of the generations in the 1890s. These and other similarly evocative photographs are taken from the Wicks family album, housed at the Port Washington Public Library. They provide a glimpse of bucolic times and family togetherness.

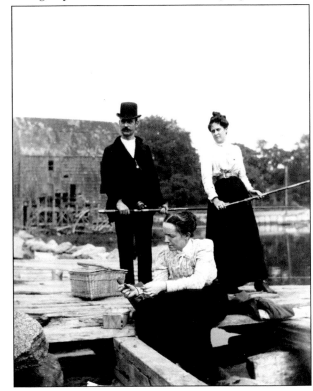

Here members of the Reid family are fishing near the Mill Pond in 1898. Fish was a great staple in the diet of Port Washington families, surrounded by water and easily accessible piers and fishing spots. The straw and wooden baskets and handmade fishing rods and lures were part of the maritime traditions that are preserved as memorabilia today.

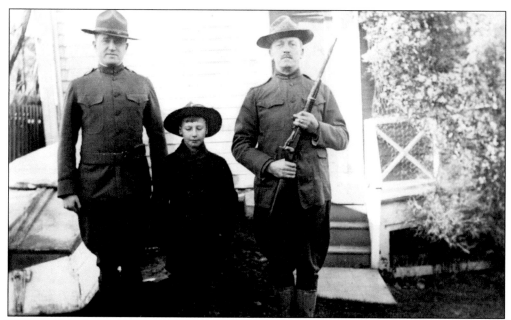

William C. Leiber Sr. was born in 1870. He headed Leiber, Schrenkeisen and Nobbe, New York City tile manufacturers. With his box camera he documented his family activities and Manhasset Bay. In elegant albums he meticulously provided names, dates, and locations. Here, from left to right, Uncle Paul Leiber (a career army officer), Willie, and William stand at attention in their World War I fighting uniforms on December 2, 1917.

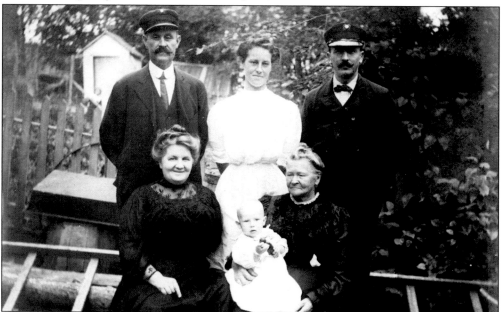

William C. Leiber and Emma Louis Knauth were married on June 8, 1902. Upon the birth of their first son in 1908, William Sr. wrote, "Not a lifeless, useless toy, we've a lively, bouncing boy!" The *Port Washington News* of February 15, 1908, hoped "the blue-eyed boy may grow into noble manhood and fill the sunset of his parent's life with comfort and happiness such as can only come from a dutiful child."

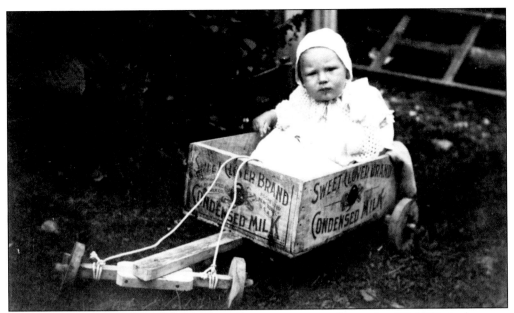

Young Willie Leiber sits in a homemade milk crate wagon on September 20, 1908. As he grew, his father documented his day-to-day activities and interests. They turned out to be navigation, boat piloting, firefighting, duck hunting, and model boating. As an adult, Willie remained in Port. He invented Leiber's Lightning Navigator and became a writer for *Mechanical Models*, the *Model Maker*, and the *Model Craftsman*.

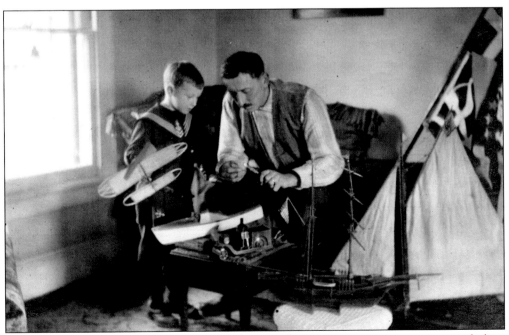

William C. Leiber Sr.'s informal family photographs capture patience, respect, and deep connections to his relatives. For many Port Washington families, building boat and seaplane models was a major recreational activity. The traditions of model-making, with burgees and scale models in the background, are shared here by father and son on December 22, 1912.

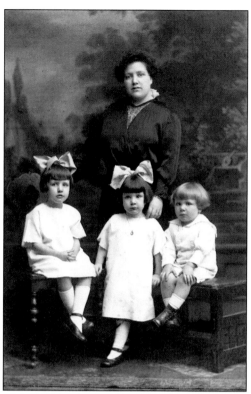

Over the course of a lifetime, families accumulate records. The archives in the Port Washington Public Library contain photographs of children's milestones, immigrants' lives, rites of passage, formal events, and everyday lives and activities. They are a record of how people lived and were represented, sometimes more than 100 years ago. Many of these people are unidentified. This is a c. 1900 example of a previously unpublished photograph from the Mason collection.

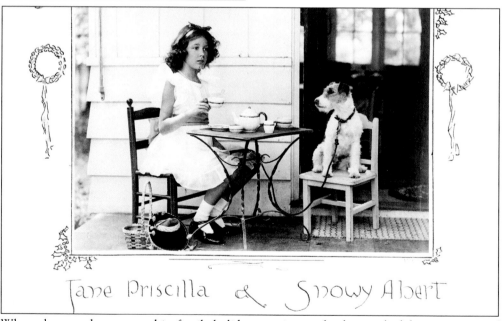

Jane Priscilla & Snowy Abert

When photographs were used in family holiday greeting cards, they evoked favorite scenes of the past year. This moment on the front porch of the Sousa house in Sands Point features Jane Priscilla Abert having a tea party with her dog Snowy in 1934. Her grandfather, John Philip Sousa, was one of Port Washington's most prominent citizens and inspired a generation of Port Washington youngsters to play in marching bands.

Alfred Fraser (1840–1915), originally from England, purchased a home in Sands Point in 1895 named Ashcombe after his wife's family farm. Raised in Port Washington, the children stayed on and became involved in banking, local politics, teaching, and yachting. This photograph, taken in September 1930, shows Martha "Patty" Willetts Mott Fraser with the young set in Sands Point. Her husband, Alfred Valentine Fraser, was a mayor of Sands Point.

With the development of the box camera in the 1880s, photographers had more mobility, were better able to afford the equipment, and could leave the studio. These family photographs provide information about layouts of rooms, styles of furniture, and size of homes. They reinforce family pride and suggest a sense of security and comfort. Pictured here are Richmond, Kimball, and Pauline, children of Mr. and Mrs. George Perley of Ivy Way.

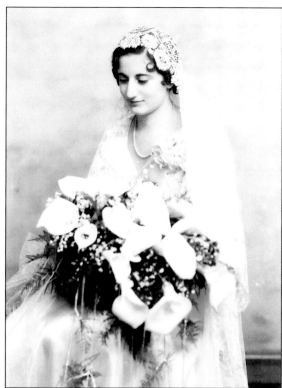

This photograph celebrates the details of the elaborately decorated wedding gown, the facial expressions, the jewelry, and the floral arrangements that were in vogue in Port Washington in the 1930s. Formal photographs were taken at weddings because the ceremonies shared a solemnity and reinforcement of the previous generations' nuptials. This picture, of Mrs. Nick De Anuzio, was taken by Stanley Gerard Mason in August 1932.

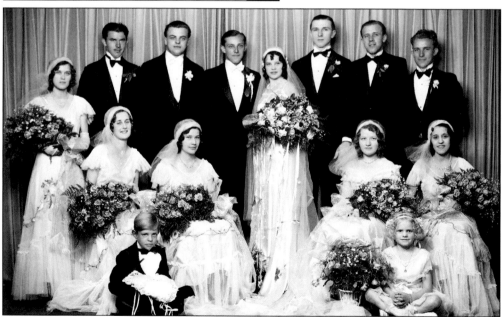

When professional photographers such as Stanley Gerard Mason worked in studios and wedding halls, they placed families in poses that express the traditional family roles and suggest age-old patterns of relationships and traits. "Stella and Benny, June 12, 1932" is one of hundreds of wedding pictures in the Port Washington Public Library's collection. It captures the elegance and ornamentation of one couple's rite of passage into marriage.

A glimpse at the labors of internal family life in Port Washington in 1913 is provided by this advertisement in the weekly *Plain Talk* magazine, dated April 12. Concerned with sanitation and coal pollution in the home, the editor, H. K. Landis, was a major promoter of clean families and clean living throughout Nassau County and New York City in the second and third decades of the 20th century.

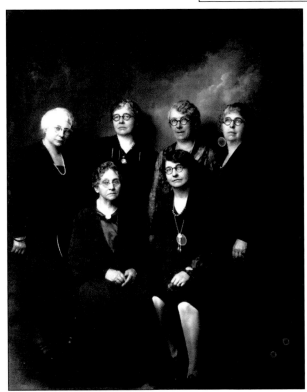

Like oil-painted portraits, family photographs have become a household adornment. They enable people to look at relatives they have never seen. They help children acquire a visual sense of their past, understand their genealogy, and imagine the forebears they see in the pictures. The six Dayton sisters, in a photograph from 1920, stare straight ahead at the camera and suggest a unity that cannot be destroyed.

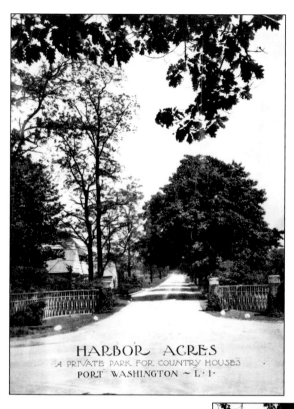

HARBOR ACRES
A PRIVATE PARK FOR COUNTRY HOUSES
PORT WASHINGTON ~ L·I·

Port Washington's high-end country life was promoted by real estate developers in the 1920s and 1930s. Harbor Acres was one of the subdivisions of the William Bourke Cockran estate. Cockran (1854–1923) was a congressman and major landowner who donated property along Middle Neck Road in 1901 to build St. Peter's of Alcantara Catholic Church.

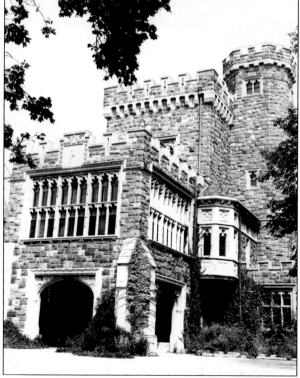

Castle Gould, planned in 1901, was designed by Richard Howland Hunt (1862–1931) in the rustic style of Castle Kilkenny in Ireland. The enormous stable complex, shown here, included the garages and servants' quarters. The main house was filled with people in the summertime, and Charles Lindbergh wrote his memoir *We* in the "Sound Room" during a four-month stay at the Harry Guggenheim estate in 1927.

In the early 20th century, western Long Island's easy access to New York City and dramatic coastline attracted the attention of millionaires. In Port Washington, the Guggenheims, Astors, Goulds, Belmonts, Whitneys, Hearsts, Holmeses, Fleischmanns, Vanderbilts, and Luckenbachs built baronial mansions that provided employment for many. Seen here is a portrait of Port Washington's Charles Hanson, Susan Dinn (daughter), and Margaret Hanson in 1950. Charles Hanson ran the John W. Davis estate in Locust Valley. (Courtesy of Susan and Alan Dinn.)

The 20th century is sometimes called "the century of photography." Here Mrs. Seymour Johnson, in a black v-neck dress and pearls, sits with three generations of women in her family in the library of her home in Port Washington in November 1946. The formality of the piece, the ornate fabrics, and the setting reflect a prosperous life.

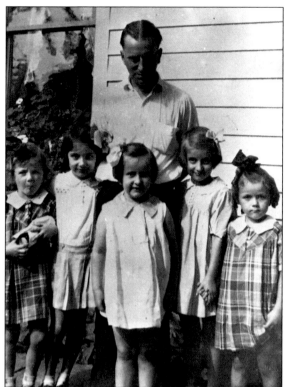

The two little girls dressed in matching plaid are the Seaman sisters, Ruth Lee and Peggy, at their annual visit upstate to see family in the 1930s. The Seaman-Needham family ran a well-known Main Street plumbing and retail hardware store, starting in 1922. Their store, with its oiled hardwood floor and pressed metal ceiling, carried everything from Yankee Clipper sleds to rolls of cord and whisk brooms.

Sand mining was a major industry. Barrack housing was provided by sand mining companies such as Goodwin and Gallagher and Metropolitan. In the 1930s, a school and library were built along East Shore Road. Seen here are Carole and Barbara, Santoli family members, who grew up in the sandbanks in the 1940s. In the summer, miners' children cooled off in swimming holes and attended camp Col Sa Gra (Colonial Sand and Gravel Company).

Above is Megan Rumbelow's father, Edmund, who came to Long Island in 1939 to work for Harry Guggenheim in the dairy barn. He left Wales for the employment opportunities the estates offered.

On a regular basis, members of the DeMelas family and their friends gathered at the beachfront for some free time, a typical day off in the 1940s. During the week, there were no eight-hour shifts for the sand miners. It was sun up to sun down. As one worker recalled, "I used to see my father come home so tired that my brother and I used to have to sit and bathe him and get him in bed. Four o'clock the next morning, back to work again."

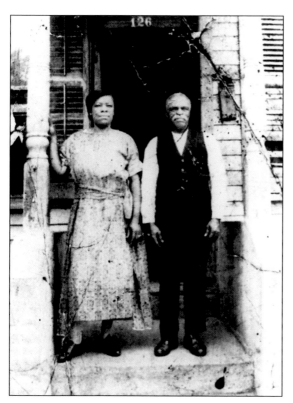

Betty Robertson and Alan Goode migrated from North Carolina around 1910. They were part of a wave of people who came to Port Washington to find work and escape the threat of racial violence. By the 1930s, a small African American community had grown up along Harbor Road. The Goodes lived at No. 126 for more than 50 years.

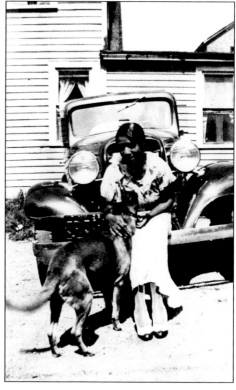

Port Washington has one of the oldest African American communities on Long Island, passing down six generations of living on and around Harbor Road, with family matriarchs Dorothy Dumpson, Minnie Biddle, Florence Longworth, Marjorie Biddle, and Phoebe Townsend. Pictured here is Marjorie Biddle with her dog Teddy in 1939. She was one of Minnie Biddle's daughters who, with her sister Florence Longworth, was a pillar of the community for more than 70 years.

Three

LEISURE AND CULTURE

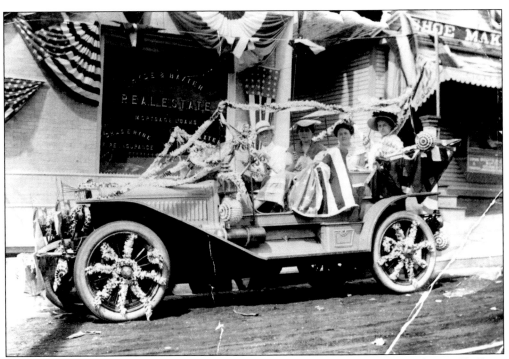

The legendary 1911 Port Washington Carnival was a weeklong extravaganza. It featured balloon ascensions, field and water sports, firemen's contests, parades, concerts, a performance of HMS *Pinafore* on a specially created dock, and an illuminated boat pageant. To further call attention to the delights of living in Port Washington, this decorated car was parked in front of Hyde and Baxter's real estate office at 277 Main Street.

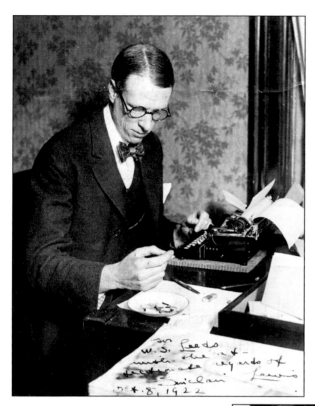

Adding to Port Washington's colorful past was a community of writers and artists. Sinclair Lewis was among them, pictured here at his typewriter in 1922. He lived at 20 Vanderventer Avenue in 1914 and did much of his work on his third novel, *The Trail of the Hawk*, while commuting to New York City where he was an editor and publicity man for George Doran.

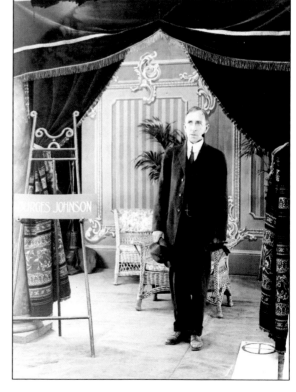

Burges Johnson, seen here around 1910, was an editor at Harper Brothers and moved from Manhattan in 1906. He built a house at 24 North Washington Street and became involved in the library, men's club, school, and Boy Scouts. Johnson chose Port Washington for its "clean water, lack of crowds and easy transportation." The Johnsons were responsible for attracting the Lewises, Norrises, Benets, and Foxes to Port Washington. They were followed by O. Henry and Don Marquis.

One of Port Washington's most famous residents was John Philip Sousa. He was scheduled to conduct the high school band in its first annual concert but died a few weeks earlier. "The Stars and Stripes Forever" march was memorialized by planting a white oak, Sousa's Tree, at the Main Street School. The John Philip Sousa School, Sousa Drive, and the Sousa Band Shell, inspired by Gay Pearsall and Floyd and June Mackey, are also named in his memory.

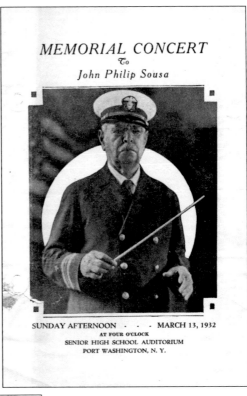

MEMORIAL CONCERT
To
John Philip Sousa

SUNDAY AFTERNOON · · · MARCH 13, 1932
AT FOUR O'CLOCK
SENIOR HIGH SCHOOL AUDITORIUM
PORT WASHINGTON, N. Y.

John Philip Sousa (1854–1932), the renowned composer and band conductor known as "the March King," lived in Port Washington from 1914 to 1932 at 14 Hicks Lane (Wildbank). Pictured here in 1919 with his daughter Jane Priscilla, he is perhaps reading fan mail. Teddy the dog is included. In his spare time, Sousa liked horseback riding, sledding, tennis, dogs, and trap shooting.

43

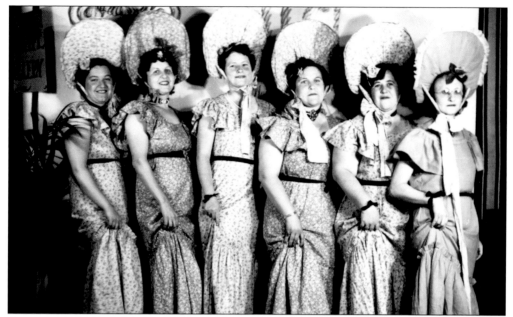

Dress-up parties and Gay Nineties gatherings, which cost 25¢ to attend, were a popular social activity in Port Washington and around the country in the 1940s. Proceeds were often donated to charitable and political causes and campaigns. Such events were usually attended by professional women and wives, and local photographer Stanley Gerard Mason was invited to record them for posterity.

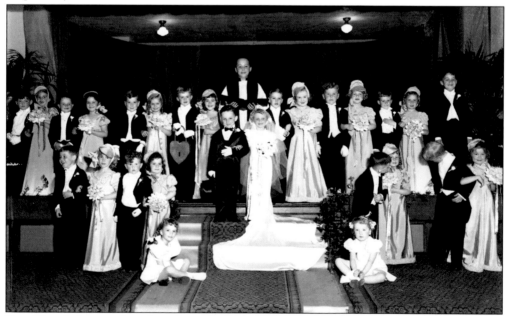

Tom Thumb theatricals and mock weddings were all the rage in the 1920s and 1930s. This one took place on April 29, 1938. Some of the participants were Jack Tangerman, Jane Bulwinkel, Fritzie Marvin, and "Sister" Southwood as bride. Preparations took months, and vows and wedding rings were exchanged with much fanfare. Perhaps as practice for the rules that lay before them in adulthood, these events were taken quite seriously.

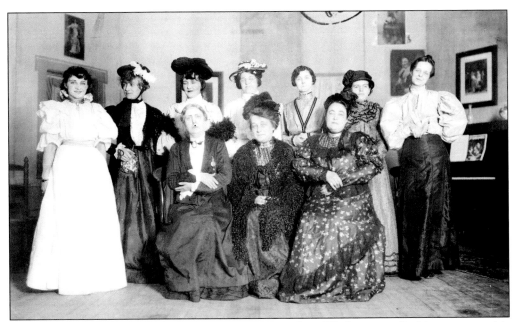

Community theater was and is a major pastime in Port Washington. Striking a pose, this group of spirited ladies appears to be engaged in an amateur theatrical evening. Players are identified as (first row, from left to right) Marian Neary, Gertrude Lowry, and Jane Deane White; (second row, second and third from right, respectively) Genevieve Decker Wallingford and Ruth Hewitt Harrison.

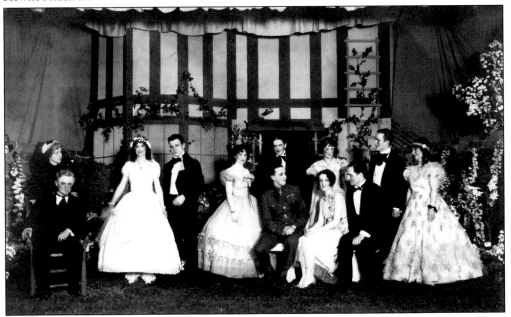

The Players Club was another local theatrical group active in the 1920s. The original officers were Cedric Crowell, Percy Shawcross, Charlotte Norton, Herman G. Brock, and Helen Wicks Reid, who was one of the founders. The club performed in the local high school and junior high school. *Smilin' Through* was a typical Players Club theatrical, with professional scenic effects, lighting, and a volunteer property committee chaired by Mrs. Frank Miley.

Kathleen Norris lived at 20 Vanderventer Avenue in 1931. Her biography describes "an unusual house, as sound as a little fortress, set in a meadow that ran down to a pond." Her husband, Charles, was on the *American Magazine* staff. Her sister Teresa and William Rose Benet lived nearby on South Maryland Avenue. Frances Hodgson Burnett, a friend and author of *Little Lord Fauntleroy* and *The Secret Garden*, lived two miles away in Plandome.

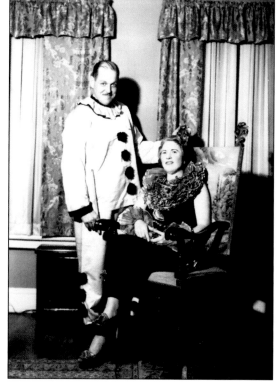

Theme and holiday parties were sometimes organized in order to raise money for good causes in Port Washington. A 25¢ admission fee was charged for this Halloween party in 1939. According to a written list of the time, it was attended by residents from Baxter Estates, Chelsea Drive, Main Street, and Briarcliff Drive. Partygoers paid their fees and dressed up to impress their friends and help local charity. Seth Thayer and Mrs. Henry Alker are pictured.

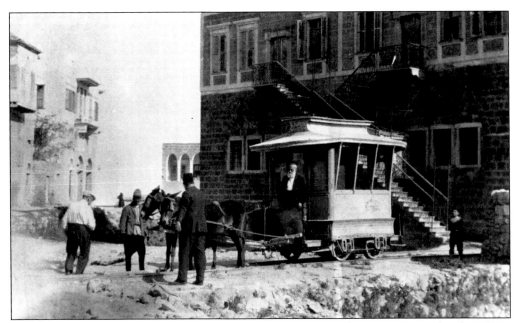

Fontaine Fox (1884–1964), the celebrated "Toonerville Trolley" cartoonist, lived in Port Washington from 1914 to the 1930s. His "Terrible Tempered" Mr. Bangs, the "Powerful Katrinka," Banker Grey, and Old Man Flint were small-town characters who earned Fox a syndication in over 200 newspapers and $1,200 a week. This personable trolley, with its "Skipper" in front, made its last run in Pelham on August 31, 1938.

The Play Troupe, the oldest amateur theatrical group in Nassau County, was founded in 1927 when nine families gathered to read plays. It developed into an acclaimed membership organization, charging $5 annually, with committees, partnerships, teen summer theater, and coaching. In this production of *The Forest Ring* (around 1941), the leads were Lois Shore ("Jane Adams") and Betty Barr ("Moss Bud"), playing a forest creature and fairy princess.

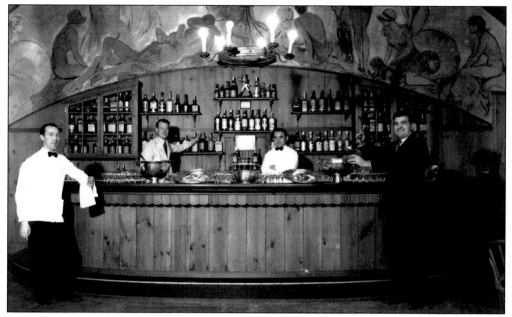

Prohibition, which banned the sale and intake of alcohol, ended in the 1930s. At that time, Port Washington saw a surge in the number of bars and restaurants serving liquor. One of the most elegant was at the North Hempstead Country Club, located on the Burtis farm between Port Washington and Roslyn. It was famous as a spot for dancing and golfing, and the bartenders in this 1930 photograph seem pleased with their plentiful supplies.

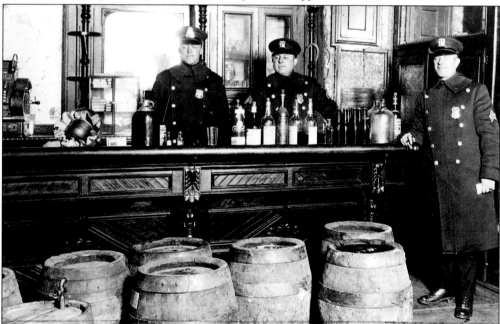

On January 16, 1920, the 18th Amendment to the United States Constitution made drinking alcohol illegal. "It was an era," wrote *Port Washington News* editor Ernie Simon, "when the most popular guy in town was the one who knew where the best 'speak easy' was." Police raids on barrooms were frequent, such as this one at the Cove Inn.

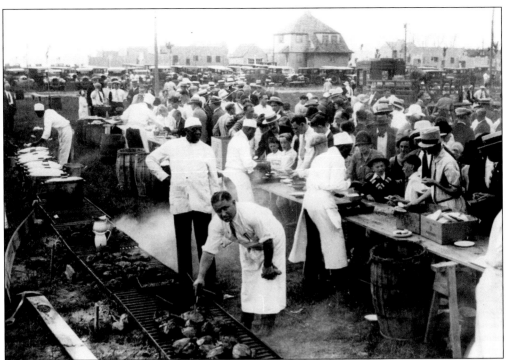

One way of spending time on weekends was to attend barbecues, such as this GOP food giveaway on Manhasset Isle in August 1928. It raised enthusiasm for the Republican Party by offering giant vats of clam and oyster stew, 1,600 pounds of barbecued beef, 6,000 ears of corn, 6,000 ice-cream bricks, 6,000 cans of soda, and 1,000 pounds of coffee. By the end of the day, 10,000 people had attended.

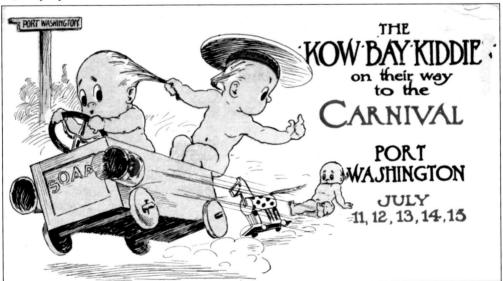

The 1911 Port Washington Carnival was spearheaded by Burges Johnson. A grandstand with a capacity of 1,000 was erected to hear United States congressman and Sands Point resident Bourke Cockran address the crowds, who had come to help "put Port Washington on the map." Publicity for the event included this postcard geared to families and their youngsters.

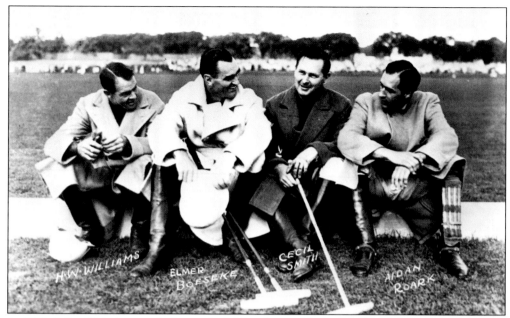

In 1922, Julius Fleischmann built a polo field with a stable for 24 polo ponies. In this picture, polo players (from left to right) H. W. Williams, Elmer Boeseke, Cecil Smith, and Aidan Roark take a moment to socialize. Other greats on the Sands Point polo field were Tommy Hitchcock, Devereaux Milburn, Watson Weeb, Laddie Sanford, Roger Strawbridge Jr., J. P. Grace, Winston Guest, Ogden Phipps, and many more.

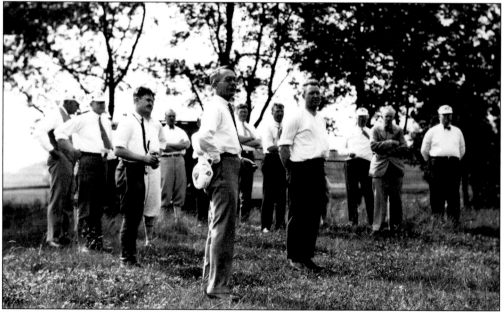

Founded in 1925, the Port Washington Lions Club sponsored leisure activities for the public at its large playing field off Sandy Hollow Road. Members such as those in this picture taken in 1929 looked forward to the annual Cow Bay Fair, horse show, antique car rally, and sporting events for youth. Former New York City mayor Robert F. Wagner was a member when he lived in Sands Point.

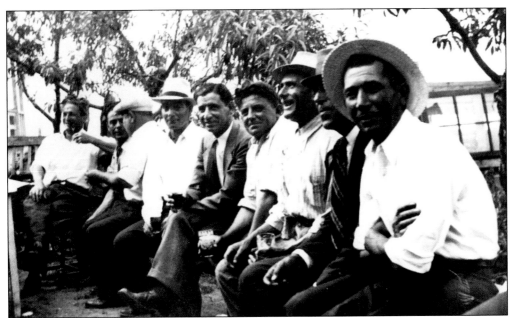

Ethnic groups in Port Washington maintained their own cultural traditions when they first arrived in America. In the 1930s, for the Italians, Sunday gatherings at a relative's house involved all-day cooking, preparations, and eating. Supplies came from Langone's and Marino's stores, located in the sandbanks. The relaxation of the men is in sharp contrast to the rigor and dangers of their daily jobs as sand miners. (Courtesy of Nancy Palen.)

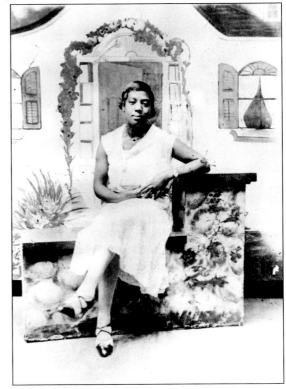

Marjorie Biddle, born in 1904, was a member of Port Washington's historic African American community who settled around Harbor Road, east of the Mill Pond. She and her sister Florence sometimes traveled to Rockaway Beach in the family's old Reo. This outing in 1918 included posing for pictures against a cottagelike back screen.

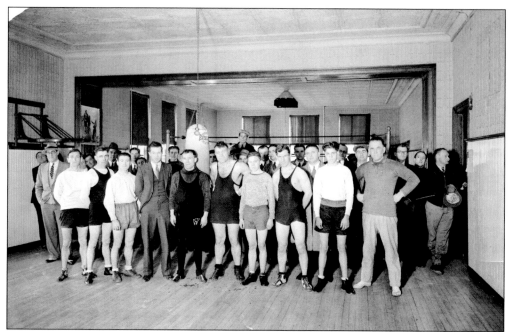

Amateur and professional boxers used the gymnasium at the old Sands Point School No. 2 to keep in shape and prepare for bouts. In the front row of this picture are Chart Henderson, Paul Terberg, police chief Steve Webber, and others. In the back is Jack Floherty wearing a suit and hat. The man sixth from the left in the first row, Tom Heeney, fought Gene Tunney in 1929.

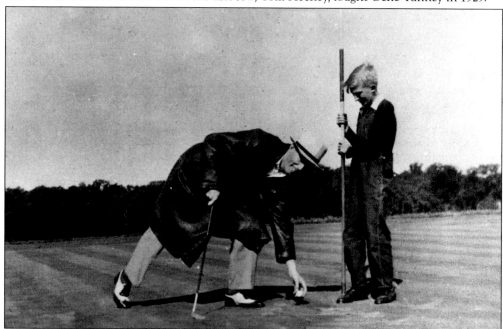

In 1918, the Cornwell farm was sold to George E. Reynolds, of the tobacco family, who built the back nine holes of the current Sands Point golf course, near the polo fields on the Fleischmann property. Caddies were recruited from local families, such as the Mahoneys, who farmed on the site of the present Sands Point Club House. This is Jerry Roche after a tee shot in August 1938.

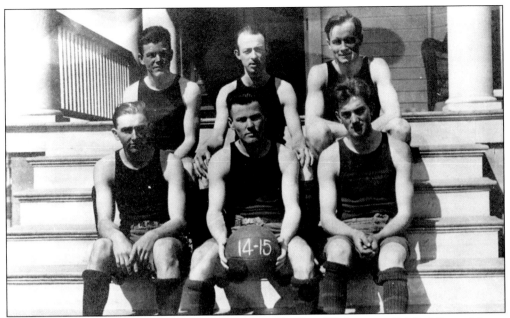

One of the wonderful historical photographs from the Port Washington Public Library Mason Studio collection depicts a local basketball team in 1914. The photograph was taken on the Griscoms' front porch, at 8 Madison Street. From left to right, players (identified by Ruth Lee Needham) are (first row) Walter Smith, Walter Griscom, and Chester Crooker; (second row) Fred Griscom, George Muller, and Alison Wysong.

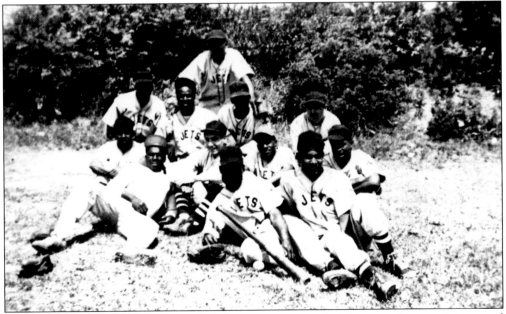

Recreation in Port Washington included sports teams and clubs, waterfront activities, and athletic clubs. Port was a great baseball town starting in the early 1920s. The high school Main Street field was crowded every afternoon, and twilight games drew over 1,000 fans. The Jets, pictured here in 1951, were proud of their record. Their predecessors were the Port Washington Colored Stars, starring pitcher "Big Ruby" Townsend and catcher Howdy Dumpson.

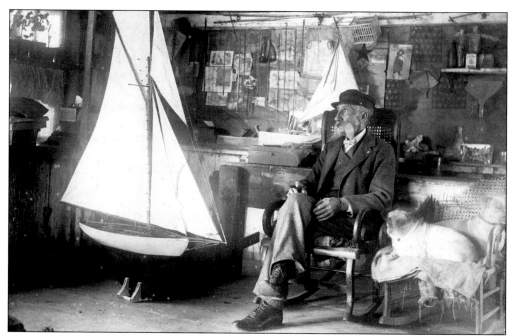

This evocative *c.* 1900 photograph portrays an old-timer simply known as "Uncle John" and his canine companion, in a space that reminds them of a lifetime spent around Manhasset Bay. The personalized objects represented here include handmade rods, traps, and models. Descendants of baymen continue to use their leisure time to build models, do scrimshaw, rig sailboats, race iceboats, carve decoys, and make fishing lures—using 21st century technologies and materials.

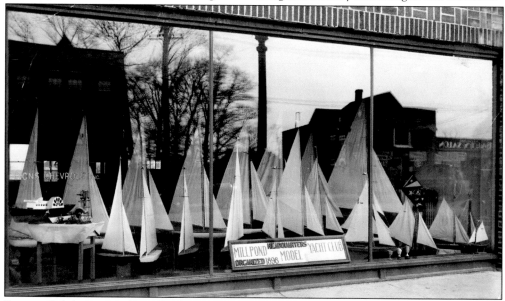

Surrounded by water, Port Washingtonians developed hobbies and leisure-time activities connected to nearby bays and ponds. In 1898, the Mill Pond Model Yacht Club was organized in a small waterfront shop. National and international trophies were award to A-class yachts and are displayed in this window on Main Street in the 1930s, along with burgees and models of racing boats.

Four

BY THE BAY

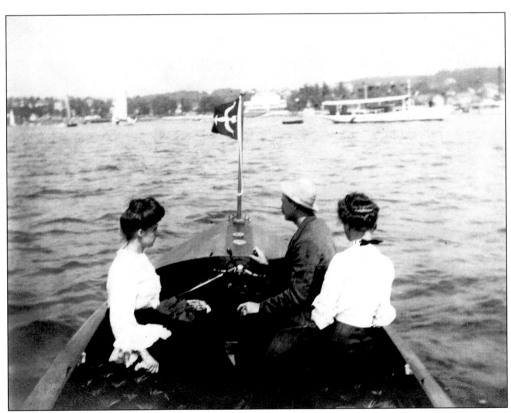

Manhasset Bay, Hempstead Harbor, and Long Island Sound surround the Port Washington peninsula. Their waters provide sustenance and recreation for residents. Celebrating July 4, 1906, in the bay, Gus Knauth, his wife, and his sister Emma Leiber enjoy a holiday ride on board the *Emma*.

Ladies in fine bathing caps are ready for a swim at Mott Point Beach, in the village of Sands Point, in 1911. Unpolluted waters and family traditions of favorite swimming spots and beaches made swimming and diving a constant source of pleasure and friendship. Aquatics, as it was called, provided bathing, exercise, sport, play, and a means of physical culture and acquiring a safety skill. Conservative swimsuits ensured modesty.

Work and fun in and on the water was not just for the wealthy and baymen. It was also a convenient resource for those who worked on the great estates. Around 1919, members of the Crampton family enjoy some time off from work on the William Bourke Cockran estate, which was located in Harbor Acres. William Crampton was superintendent from 1890 to 1920. (Courtesy of Gertrude Nicoll.)

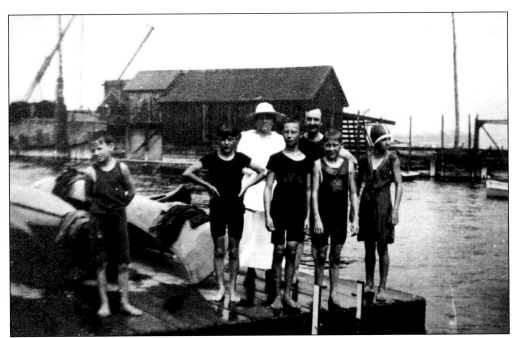

A typical summer scene in Port Washington in 1919 shows the Leiber family ready to take a dip in Manhasset Bay. As the children get ready to jump in or climb down the ladder, the senior Leibers stand in the background, perhaps posing for a photographer sitting in a boat on the water.

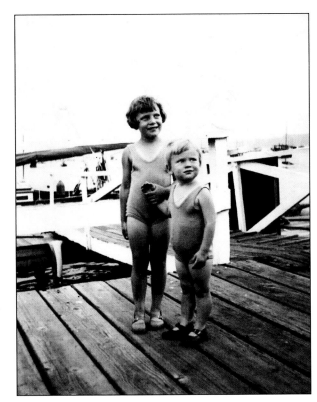

Virginia "Ginger" Marshall Martus, age 7, with her sister Claire, age 3, are at the A&R Marshall docks around 1937. Their father Raymond Marshall along with his brother, Montague, and father, Albert, formed a business that sold marine supplies, rented boat storage space, and built boats in Port Washington from 1928 to 1968.

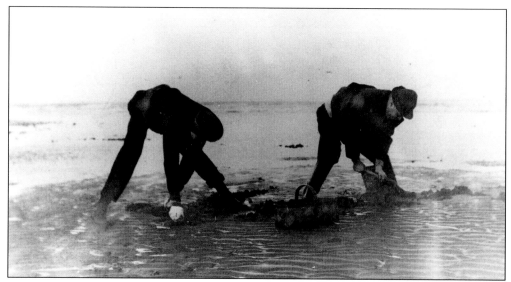

Clamming and oystering were the mainstays of Port Washington's shellfish industry in the 19th and early 20th centuries. Fishermen collected four or five bushels of clams a day. Legendary baymen such as Del Van Wicklen were called "clamdiggers." To this day his daughter, Helen Vogt, remembers recipes for "clam flodger." This Fraser family photograph depicts the nature of the work at low tide along the Sands Point shoreline near the lighthouse in 1890.

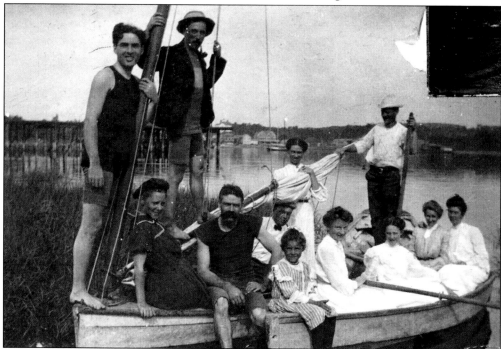

Fishing and boating define Long Island's maritime culture. From the 17th century bayman to today's angler, Port Washington has had an active fishing tradition. Today's fishermen are mostly recreational, using new types of fishing boats and equipment. However, their knowledge of habitat and seasons dates back to the working baymen who preceded them. The Hewlett family displays its style in this photograph from 1900.

Even the local newspaperman William Hyde, founder of the *Port Washington News*, enjoyed steering a boat. In the center of this 1890 photograph, he is at the helm of the sloop owned by his father, Edmond Hyde. He was one of the pioneer settlers in Port Washington, a prominent bayman who used his sloop to provide fish for local and city markets.

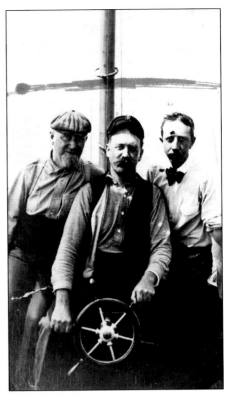

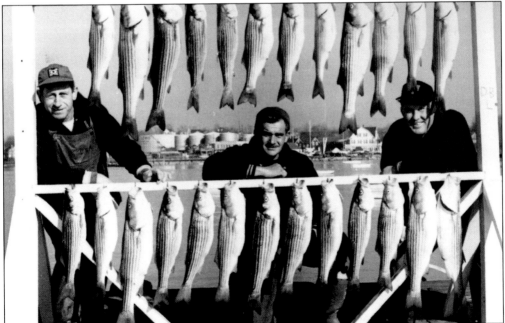

Members of the Manhasset Bay Sportsmen's Club, seen here in the 1950s, carry on the traditions of the baymen from whom they are descended. The fishing derbies, blessing of the fleet, fishing clinics, and annual awards dinner to recognize prowess in fishing, hunting, and shooting are continuations of its stated goals when it was founded in 1945.

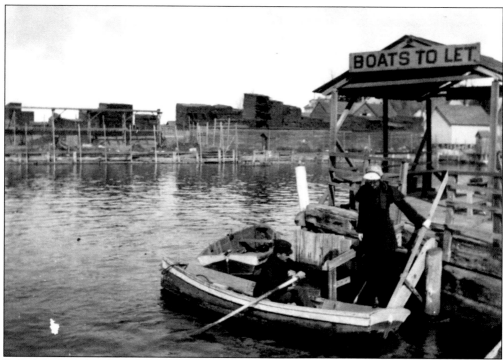

Ryder's bathing beach and rowboat rental pier, in 1903, was on Shore Road at the foot of Second Avenue. The scene in the background of the top photograph was Copp's Dock, which handled coal and lumber. The elevated structure was the railway on which coal was transported from the landing area to the delivery bins. Gradually the working nature of the bayside became more recreational so that today there is little trace of the mixed uses of the past. The lower picture shows Ed Ryder himself going in for a dip. There were separate cabanas for men and women. In the 1920s, the bathing beach was operated by Charles Cocks, who also rented out rowboats. The photographer (unknown) was located at what is about the northwest corner of the Knickerbocker Yacht Club seawall.

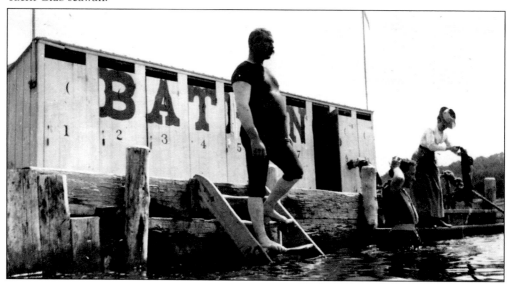

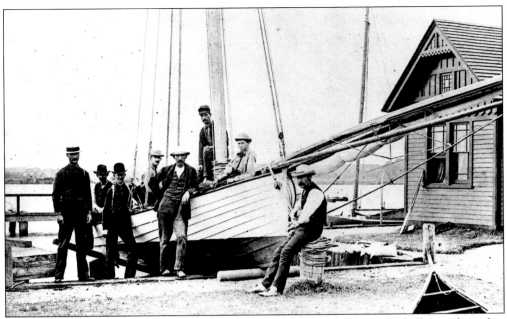

This "sandbag" boat was popular in the 1880s. It used 50 pounds of sand for ballast and was first used as a work vessel and later as a pleasure craft. Many wealthy yachtsmen owned "sandbagger" racing sloops and hired the best skippers available—oystermen who were expert in handling small boats. In 1909, they were Ed Willis, Town Reynolds, George Duryea, Silas V. Seaman, John Allen, Robert Markland, and Howell Goodale.

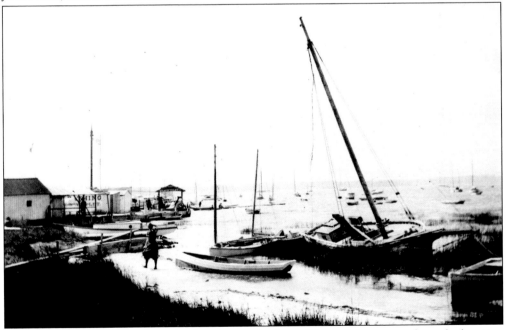

This view looks southwest from the shoreline at the foot of Second Avenue at about the location of Copp's Dock. The sign "Boats to Let" on Ryder's bathing beach is on the left. The beached sloop with a clipper bow was used for hauling oysters and other cargo. (Courtesy of the Virginia Marshall Martus collection.)

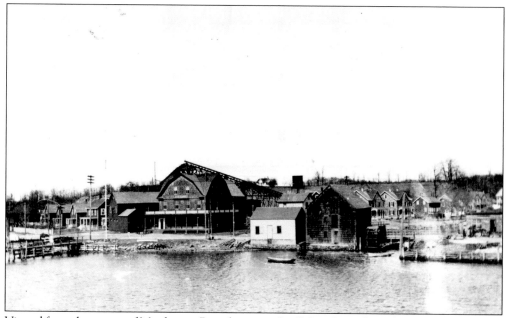

Viewed from the waters of Manhasset Bay, this mix of mill, hotel, sand trestle, and private homes provides a sense of the impact of Port's maritime setting. Transportation, work, social life, and residences were all sustained by the town's location by the water. The Renwick Hotel was one of many that became popular restaurants and is still in existence after having changed hands many times since its original proprietor, C. C. Thatcher, in 1890.

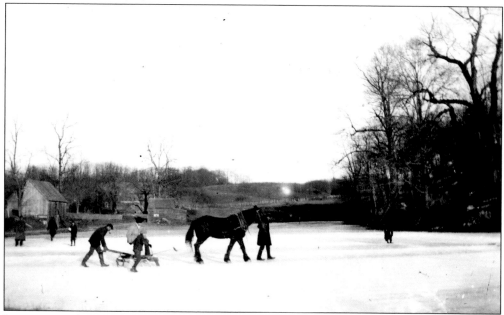

In snowy weather, preparations for all sorts of winter sports took place in Port Washington. The hills were fine for sledding and tobogganing and the frozen bay for iceboating. Local ponds, such as Baxter's shown here in 1910, were perfect for ice-skating once the horse and plow swept off the snow. Those with no horse had to shovel by hand. The ponds were especially cheery at night when bonfires burned along the edges.

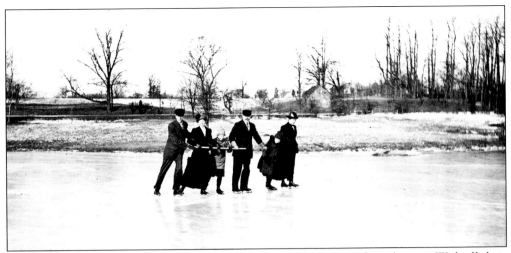

A skating party in Sands Point reveals the clothing and traditions of another era. With all their ponds frozen over, the Fraser family takes to the ice in 1913. Seen here are Patty Willetts (second from left), wife of Alfred Valentine Fraser; daughter Martha Fraser (third from left); and four other Fraser family members. (Courtesy of Peter Fraser and Richard Dunning Fraser.)

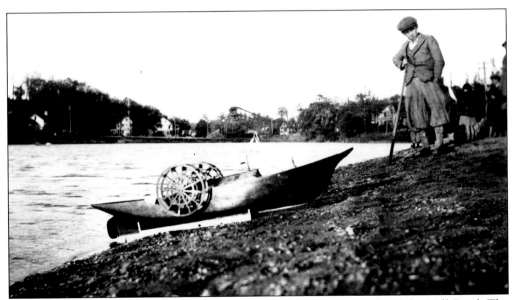

Young Willie Leiber poses next to his prized model boat on the banks of the Mill Pond. The trestles of the sand mines are seen off in the distance. The stick in Willie's hand is to capture the boat if it gets too far from shore. This is a far cry from the carbon fiber hulls, mylar sails, and remote radio-controlled models that currently race across the Mill Pond every weekend during the summers.

Children learned to swim in the unpolluted waters and small waves of Manhasset Bay. There were floats and bathhouses stretching from Manorhaven to Plandome. Docks had steps that led down to clean white beaches. Old-timers fondly remember the beach and swimming facilities under the town dock on Main Street.

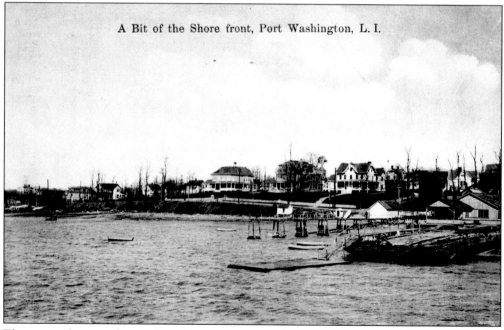

A Bit of the Shore front, Port Washington, L. I.

This tranquil postcard scene from Manhasset Bay looks toward the east and the Knickerbocker and Manhasset Bay Yacht Clubs around 1915. Founded in 1874 and 1891, respectively, the clubs engaged members in regattas, cruising races, and cup races. They also innovated new classes of sailboats, provided dining and bathing, frostbiting, iceboating, talent shows, clambakes, musicals, and camaraderie.

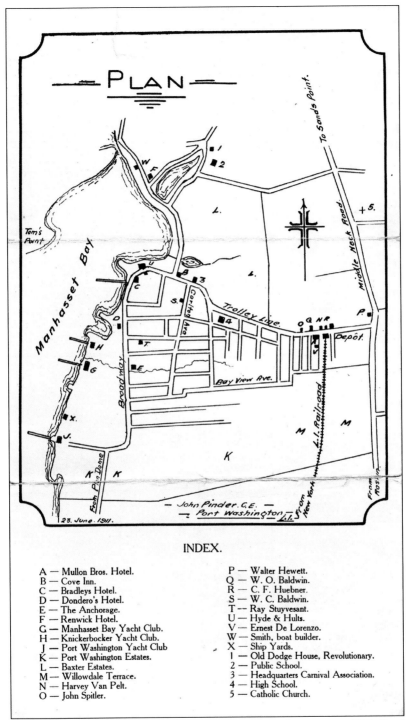

INDEX.

A — Mullon Bros. Hotel.
B — Cove Inn.
C — Bradleys Hotel.
D — Dondero's Hotel.
E — The Anchorage.
F — Renwick Hotel.
G — Manhasset Bay Yacht Club.
H — Knickerbocker Yacht Club.
J — Port Washington Yacht Club
K — Port Washington Estates.
L — Baxter Estates.
M — Willowdale Terrace.
N — Harvey Van Pelt.
O — John Spitler.

P — Walter Hewett.
Q — W. O. Baldwin.
R — C. F. Huebner.
S — W. C. Baldwin.
T — Ray Stuyvesant.
U — Hyde & Hults.
V — Ernest De Lorenzo.
W — Smith, boat builder.
X — Ship Yards.
1 — Old Dodge House, Revolutionary.
2 — Public School.
3 — Headquarters Carnival Association.
4 — High School.
5 — Catholic Church.

This graphic map shows the recreational appeal of Port Washington in 1911. Six hotels and numerous inns accommodated an influx of seasonal visitors, some of whom subsequently bought property. The Long Island Rail Road carried New York City travelers to the trolley line, which reached their hotel or yacht club destination.

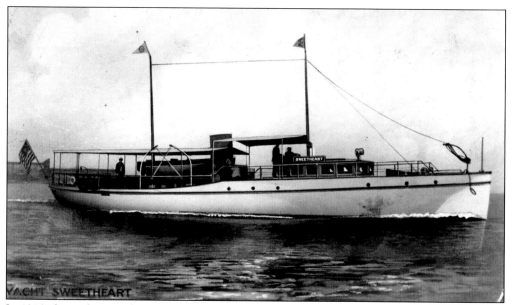

In 1916, the yacht *Sweetheart*, owned by Atwood Automobiles, was captained by Peter Petersen, a Port Washington resident of Bar Beach Road. He was born in Spindanger, Norway, in 1875. Early in the century he worked for William Randolph Hearst on his yacht in the Hudson River. Petersen's connections to Caleb Bragg as the captain of the *Masquerader* from 1921 to 1931 confirmed his reputation as a confident and capable commander.

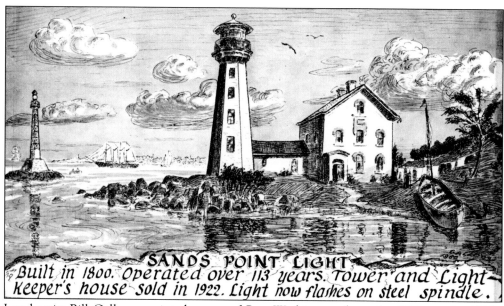

Local artist Bill Galloway painted scenes of Port Washington from the 1920s to the 1940s. This one features the Sands Point Lighthouse, a prominent feature of the coastline that stands 80 feet high. It aided mariners past the rocky reefs from 1809 to 1922. In private hands since 1924, its most famous owner was William Randolph Hearst, who, in the 1930s often used it for lavish parties.

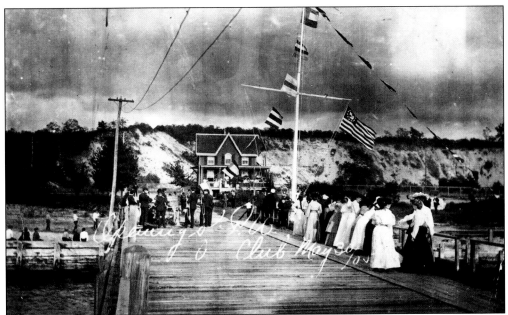

On the opening day of the Port Washington Yacht Club, May 30, 1905, note the sandbanks in the distance and the brass band getting ready to play. All four of Port Washington's yacht clubs—Knickerbocker, North Shore, Manhasset Bay, and Port Washington—have undergone major renovations over the years, and memberships have waxed and waned, but they are still well-known centers of boating, social life, racing, and teaching youngsters nautical skills.

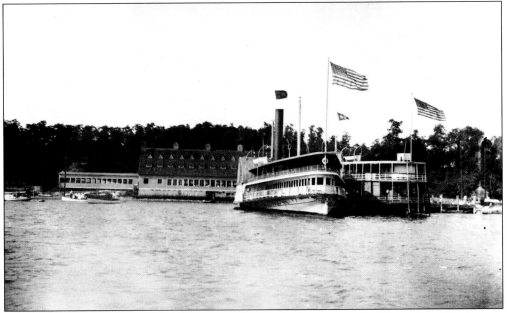

At the dawn of the 20th century, excursion boats made frequent weekend trips from Manhattan and the Bronx to Locust Grove, in Manorhaven, in an area called Chicken Point. Food and entertainment were provided in a pavilion next to the dock. The area had 500 feet of shore, good anchorage, and deep water. The surrounding 11 acres of land was leveled in 1925 by the Bayside Homes Company development company.

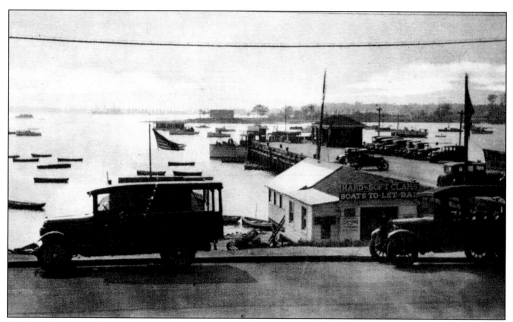

In the distance, the town dock served as a center of social activity in Port Washington. This postcard from the 1930s captures a scene that is still readily identifiable today, except for the automobile styles. Harbor patrol Frank Hudock remembered that "when the wind was northeast everyone would come into the corner here, just exchange tales . . . it used to be the spot for news more or less for the whole town."

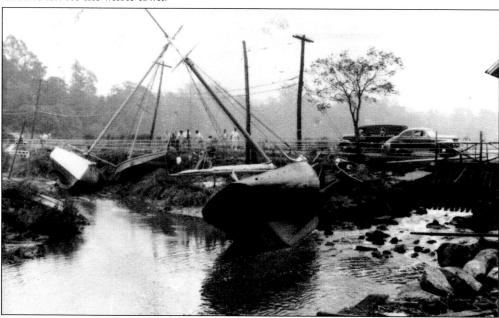

Disaster struck Port Washington in a big way with the hurricane of September 21, 1938. Boats were lost, roads torn up, lives taken, homes destroyed, and trees felled. At the Port Washington Yacht Club, almost 100 boats were carried on the tidal wave and washed up on the club beach, as witnessed by this photographer. At least 400 boats in Manhasset Bay were damaged or sunk. (Courtesy of Virginia Marshall Martus.)

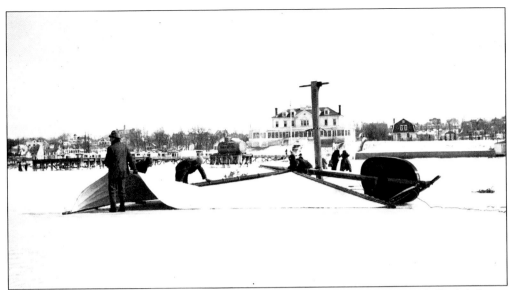

Iceboating on Manhasset Bay was a common winter sight in the early 1900s. Skiffs glided over the ice at speeds of over 26 miles per hour. The Manhasset Bay Yacht Club is in the background as these boaters prepare for a race around 1914. Some of the champion iceboats in 1936 were *El Pampero*, *Whirlwind*, *Knickerbocker*, *Polar Bear*, *Feather*, and *Papoose*. (Photograph by Robert William Fraser.)

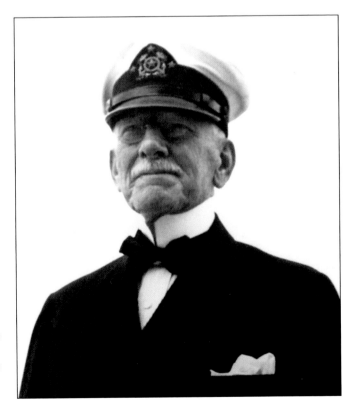

Commodore George "Pop" Corry, born in 1863, was called the "Father of the Star Class" boats. He moved to Port Washington around 1900 and was a founder of the Manhasset Bay Yacht Club and owner and skipper of the famous *Little Dipper*, originating a fleet of Star-class boats in 1911. They were small, affordable, and designed to suit the waters of Long Island Sound. Star boats were once the largest class of one-design racing boats in the world. This is Pop Corry in a portrait from 1935.

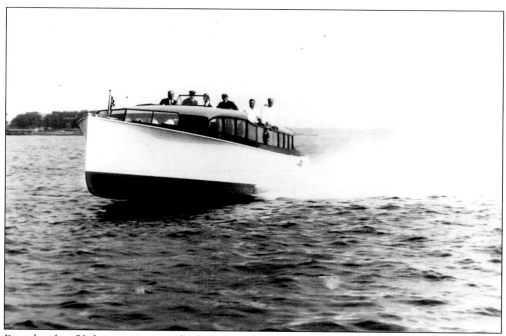

Rascal, a fast 50-foot cruiser, was built in 1929 by the Purdy Boat Company and designed and owned by Caleb Bragg. It took the family between their houses in Port Washington and Montauk and could go 57 miles an hour. A similar racer, *Rowdy* was built by Purdy for Carl G. Fisher, who developed the Bayview Colony residential area in Port Washington.

Protected anchorages and an easy commute lured many Knickerbocker Yacht Club members from New York City, where the club originally met, to Port Washington. The Knickerbocker Yacht Club Commodore Gilchrist Trophy was awarded in the 1920s to this glamorous recipient. Other trophies are awarded for annual powerboat races, one-design champions, active participation in winter yacht racing, service to the club, best skipper, "blue water sailing," yachting achievement, and more.

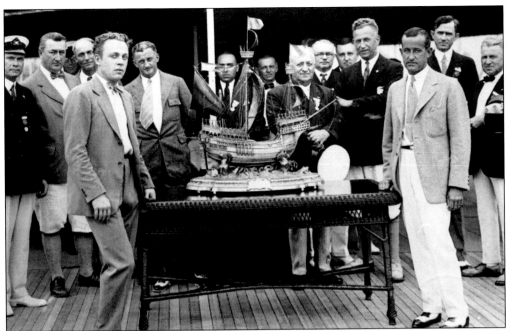

Caleb S. Bragg was an all-around sportsman. In addition to his aviation and automobile thrills, he also raced speedboats on Manhasset Bay in the 1920s. In August 1925, he received the Dodge Memorial Trophy after winning a division of the Gold Cup Race for *Baby Bootlegger*. The trophy was a $25,000 sterling silver model of a galleon.

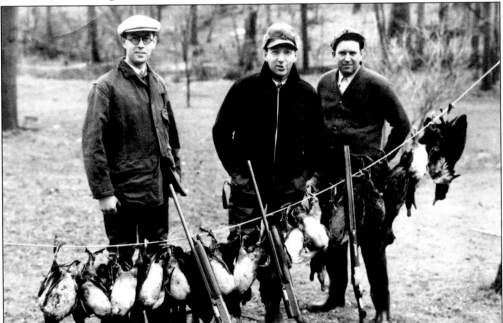

Duck hunting and making decoys and duck blinds was a way of bringing friends together, being on the water, getting dinner, and practicing shooting and wood-carving skills. This threesome consists of Bill Borer (center), chief of police of Sands Point; Art Seaman (right), superintendent of a Sands Point estate; and an unidentified hunter on the left. The year was around 1930.

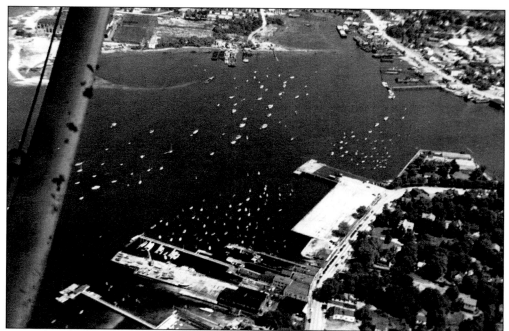

This c. 1950 airplane view of part of Manhasset Bay shows the town dock and Sunset Park in the right foreground. Shore Road is along the top to the east, and Manhasset Isle is on the upper left. The large numbers of boats in the water show the extent to which Port Washington's deep harbor is a haven for boats and boaters. (Courtesy of Virginia Marshall Martus.)

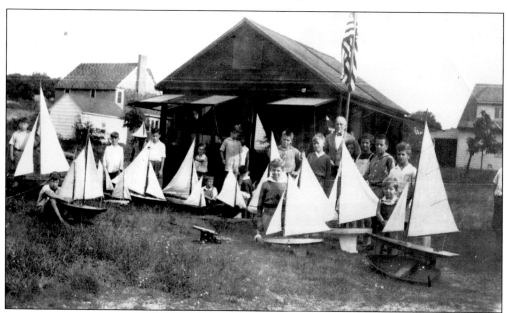

The Mill Pond Model Yacht Club of Port Washington was founded in 1898 by Charles Dodge, John Erickson, Fred Farmer, and Harold McKee. Model boating was, and continues to be, a popular pastime in Port Washington. Many of today's model makers are graduates of the Mill Pond Yacht Club, which was led by Bill Sainsbury, pictured here with a gaggle of youngsters proudly displaying their creations in the early 1930s.

Five

WORK

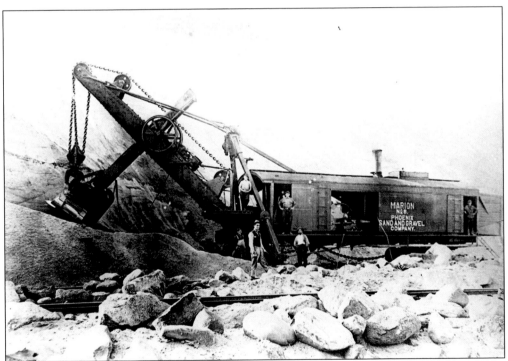

During the 1850s, many farmers found it profitable to sell sections of their property to mining companies, turning their land over to sand and gravel pit companies. Between 1865 and 1930, 100 million tons of Cow Bay sand was used for the concrete that built New York City's subways, sidewalks, and skyscrapers. The men who labored in the sand pits included this steam shovel crew who worked for Phoenix Sand and Gravel Company in 1910. A monument on East Shore Road has been dedicated to the thousands of laborers involved in the extraction.

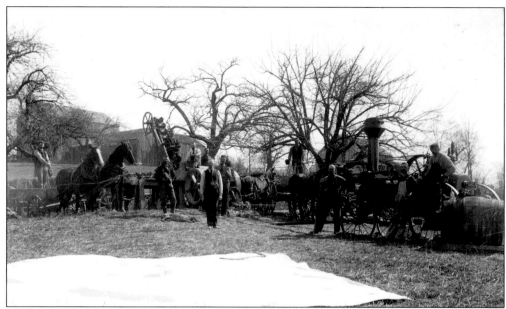

In the 1880s, Stephen Robbins Hewlett and Samuel Lewis Hewlett opened their own canning factory on Port Washington Boulevard. Produce from the 350-acre Hewlett farm was so plentiful that the brothers employed 60 workers, turning out 8,000 cans a day of tomatoes, fruits, vegetables, cider, and vinegar. They manufactured their own Puritan Brand cans with decorative labels and sold them to consumers as well as farmers for commercial production.

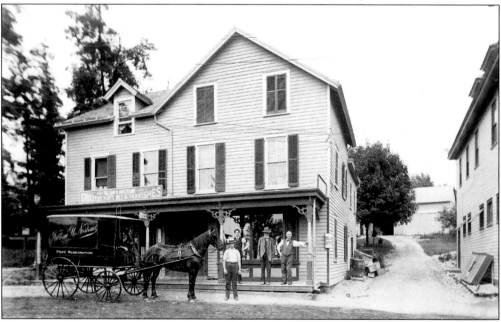

The story of business in Port Washington is in many ways a history of American enterprise during the first half of the 20th century, characterized by long hours, total family involvement and commitment, laborious work, resourcefulness, and keeping up with new developments and times. William Van Nostrand's general store was on lower Main Street, across from the present-day town dock at No. 322. In this 1905 picture, the staff is assembled in front of the building.

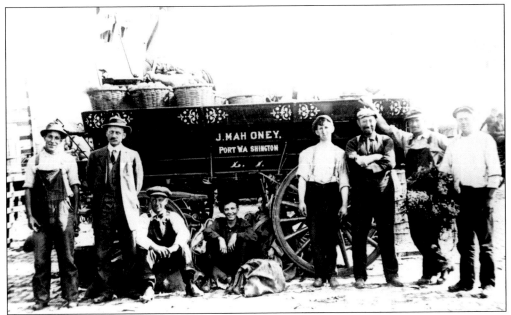

With fertile soil and an agrarian way of life, Port Washington's needs a century ago were met with bare essentials from general stores. Overland roads permitted horse-and-wagon merchants to ply their wares. The Mahoney brothers, here in 1905, were tenants on the Cornwell estate. They grew truck vegetables, cabbages, beans, turnips, and apples and took them to market in New York City, a day's journey by horse and wagon.

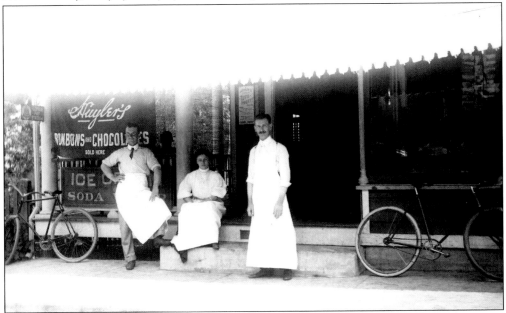

Wearing white aprons, employees await customers outside Del Van Wicklen's ice-cream parlor at 307–309 Main Street. A longtime Port Washington institution, it sold ice cream and soda and also had a Stuyler's candy counter. Its slogan was "a man is known by the candies he sends." Sugar cost 4¢ a pound in 1908, when this picture was taken. Average Americans earned $15–$25 a week.

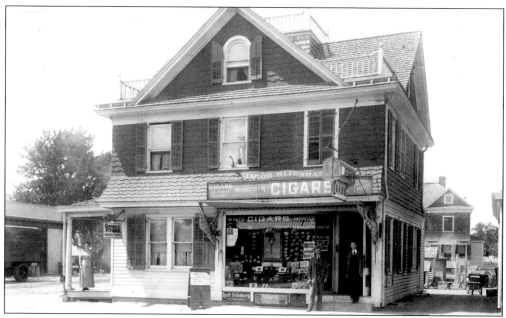

A prominent Main Street business in the early 20th century was Jacob Kliesrath's cigar store. Shown wearing a straw hat, Kliesrath had a steady clientele for his hand-rolled 5¢ cigars made from domestic tobacco. He also sold Tampa Clear Havana cigars, using a rolling blade and knife with a rounded blade. In 1917, Kliesrath sold his Main Street location, which was located opposite the Long Island Rail Road.

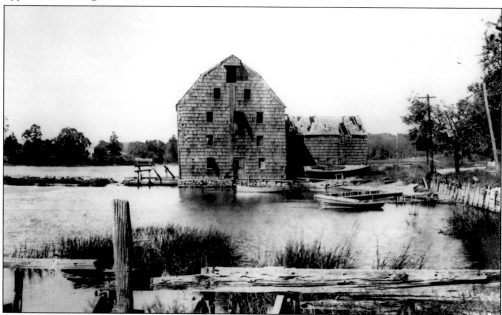

There were once two gristmills along the waterfront on Shore Road that used the waterpower of Manhasset Bay. Cocks' Mill, seen here, was probably built in 1789. It measured five stories high and produced thousands of bushels of wheat for flour that was sent to New York City. It was originally known as Motts' Mill, then Merritts' Mill, and finally as Cocks' Mill as it changed hands over the years.

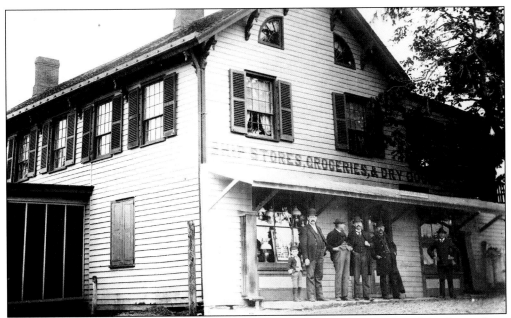

Prominent area businessmen around 1890 discuss politics and other matters of the day in front of an unidentified mercantile building in Port Washington. Selling "ship stores, groceries and dry goods," this general store would have dealt with only dry goods such as flour, beans, baking soda, and canned goods, as well as nautical parts. Perishable foods such as fresh meat, milk, and vegetables were sold separately in specialty shops or produced at home.

John E. Baxter's shop, in addition to shoeing horses, repaired farm machinery, which was becoming more complex and mechanized in the early 1900s. The tools, inventions, and techniques of an earlier era of blacksmith work gradually transferred to the maintenance of the more industrial parts of "gasoline carriages." One kind of horsepower replaced another.

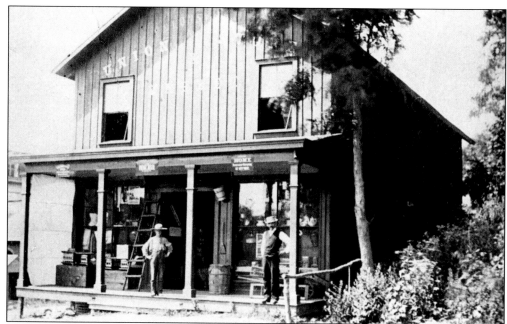

Among Port Washington's early entrepreneurs was the McKee family, who operated a general store in Port for almost 100 years. Tom McKee, Port's first postmaster, had the first McKee store for 30 years at the corner of Shore and Harbor Roads. In 1870, his son George started a second general store at 287 Main Street, pictured above, as Port's population slowly shifted from the Mill Pond area to Lower Main Street. The original building still stands, with the addition at No. 289 that George used for his coal and feed business. The inscription "McKee Building 1845" is visible under the roof beam. As an accessory to the store, the McKee store wagon, seen below, delivered goods to people's homes in the 1890s. James Hubbard (Hub) Poole Jr. drove the horse. He was a much beloved and active member of the community.

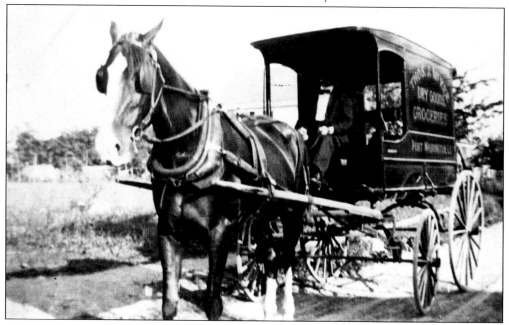

Conrad Meyer's market at the Mill Pond was also the site for the firemen's parades and tournaments that were so popular in the second and third decades of the 20th century. There were gala water sports programs, including walking "the greasy pole." The area regularly drew a big crowd of local residents, which greatly benefitted the businesses that were once there.

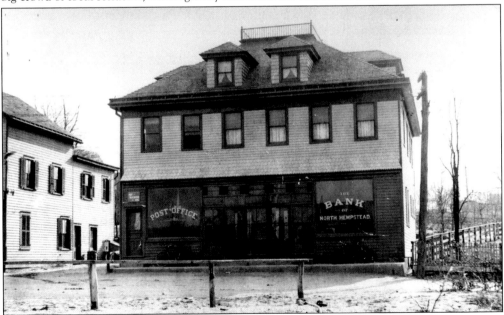

This building served as Port Washington's first post office. It was constructed by postmaster Bert Hults in 1902 and was located at No. 324 before it moved to Irma Avenue and then Port Boulevard. The next store, at No. 326, was the Bank of North Hempstead, the only bank in town from 1902 to 1919. Upstairs was the *Port Washington News* and the North Hempstead Light and Power Company.

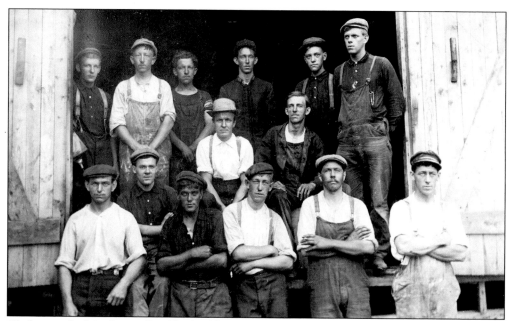

Workers at the Manhasset Bay Shipbuilding and Repair Company are seen around 1900 next to the Port Washington Yacht Club. Albert Marshall (center, wearing bowler hat) was foreman at the time this photograph was taken. He went on to found A&R Marshall, Inc., a shipyard that he operated with his two sons, Raymond and Montague. A&R Marshall was a fixture of the Port Washington waterfront from 1928 until 1969.

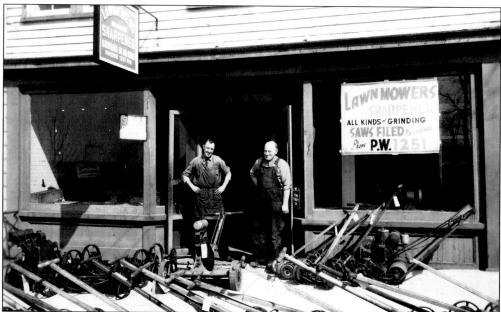

Between 1920 and World War II, summers provided a boost to the Port Washington business community as superintendents, gardeners, and cooks on newly-built estates stocked up on supplies for their July and August stays. In 1936, resident Charles Sizer opened his lawn mower shop at 9 Shore Road, telephone number 1251. The area's large homes and estates' huge velvet lawns and manicured gardens ensured a steady lawn mower repair business.

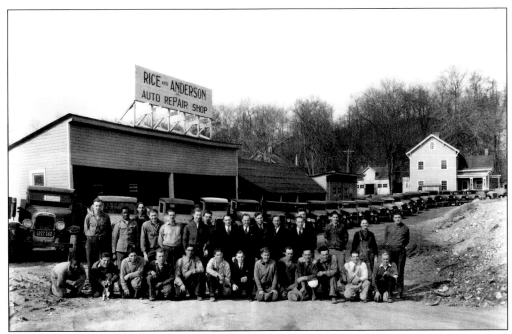

At the Rice and Anderson Auto Repair Shop on April 9, 1932, employees and owners pose in front of cars and trucks waiting for the "auto laundry," which cost $1 per wash and $1.50 for pick up and delivery. The early 1930s were a time of transition in the automobile industry after Henry Ford closed his Model T plant and began marketing the immensely popular Model A.

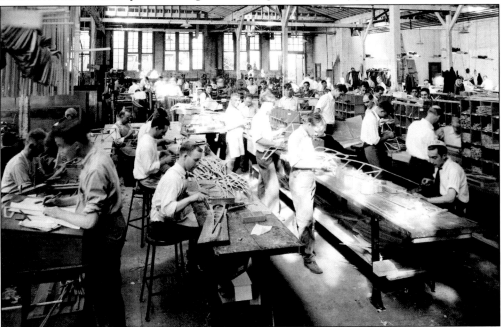

The American Aeronautical Corporation flying boat factory built in 1929 heralded the transformation of Port Washington from a quiet country retreat into to a busy manufacturing community. Workers in this photograph are assembling parts for the S-56 Savoia-Marchetti flying boats, which cruised at 110 miles per hour at sea level. (Courtesy of Joseph Gaeta.)

M. WILKINSON & CO.
AUTOMOBILE BROKERS
AGENTS FOR OVERLAND AND BUICK CARS
Port Washington Garage
Cars Repaired, Rented and Stored
Auto and Motor Boat Supplies

Taxicab and Touring Car Service any hour of the Day or Nigh

Phone 236-J **Garage opposite R. R. Depot**

KEEP COOL

Delicious, creamy, delicately flavored pure Horton's ice cream, healthful and refreshing, in large or small quantities at

NIELSEN'S
Near L. I. R. R. Station

Step in and try the New Soda Water Fountain

Old telephone directories are excellent sources of historic information. The 1931 Port Washington directory was priced at $1 and boasted it would enable residents to locate "Who carries it! Who will do it! Who can serve you!" The advertising pages were graphically laid out and supplied telephone numbers and locations.

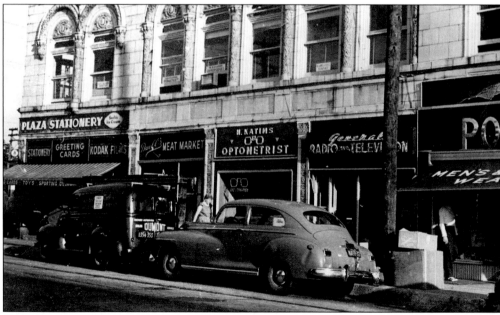

On the corner of Haven Avenue and Main Street, the ornate Plaza Building was built in 1929 on the site of the old Victoria Hotel, adjacent to the Long Island Rail Road station. It was designed as an office building, and its intricate facade symbolized the end of an era of prosperity. Located at 72–88 Main Street, its local businesses in 1949 included Plaza Stationery, Duell's Meat Market, and H. Katims, established in 1938. (Courtesy of Kenneth Markland.)

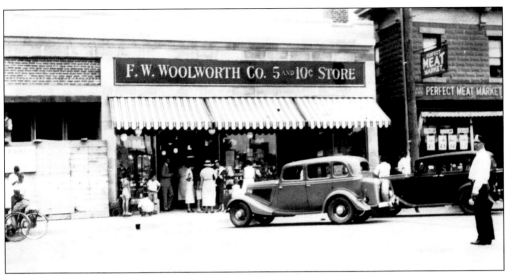

Port Washington once had its own Woolworth's, across from the train station, seen here in a 1934 photograph. Everything in the store cost 5¢ or 10¢. In addition, the lunch counter became a meeting place for members of the community. The company announced that in 1928 it was serving 90 million meals per day around the country. The Woolworths themselves lived nearby in Glen Cove. (Courtesy of Kenneth Markland.)

This unidentified restaurant, around 1925, was located on the north side of Main Street directly across from the Plaza Building and train station. Restaurant dining was a result of higher incomes and standards of living in Port Washington. By the 1940s, the list included Louie's, Chris Bar, Gildos, Manorhaven, Ligeri's, Gaffney's, Oscar's, Paradise Bar and Grill, Plaza, Moorings, Nino's, Old Post, Olaf's Tavern, Royal Café, Riviera, Stumble Inn, Village Tavern, and more.

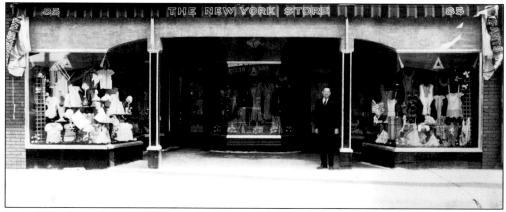

Smiles' New York Store at 85 Main Street between Haven and Evergreen Avenues was a popular clothing store for women and children in the 1940s and 1950s. It was founded by A. I. Urich and specialized in "quality clothing for less." The store was a forerunner of later discount venues in offering more competitive pricing.

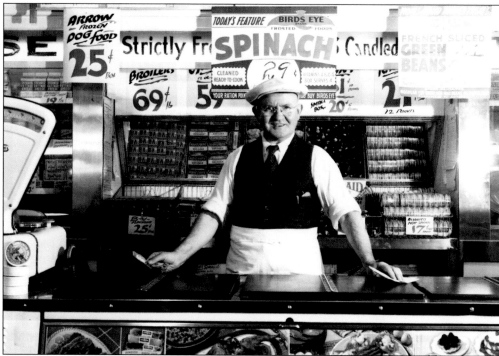

John Keaney is at the freezer counter at a Main Street store in November 1943. One of the signs in the background reveals that ration points could be used for frozen foods. They were exempt from the rationing that was applied to canned vegetables and fruits during the war. Despite the hard times of the Depression, the frozen-food industry had boomed following inventions by Clarence Birdseye in the 1920s, and Port Washington store owners benefitted.

Resident Earl Markland took this picture of the A&P (Great Atlantic and Pacific Tea Company) in 1944. Located at 25 Main Street, the chain resisted modernizing and kept old-style grocery storefront windows. Prices reflect increases experienced during the war years. In Port Washington, wartime reliance on shelf-stable meat products from Armour Star and Rose Premium brands was supplemented with fresh fish caught in local waters.

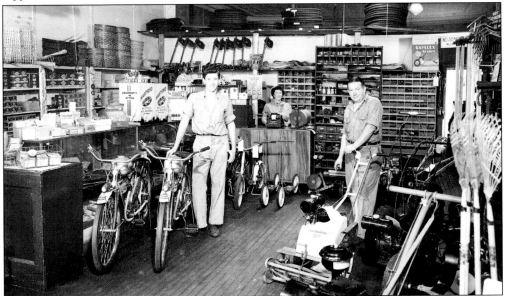

Don's bike shop and Tyson's lawn mower repair shop shared premises on 102 Main Street in 1947. Benny Tyson, on the right, carried push and riding lawn mowers, which were a status symbol and made life easier. The heavy-duty bicycles in front were mounted with Whizzers, an engine kit that made riding easier. The Schwinn bikes also featured quality and styling available on automobiles and motorcycles—such as electric horns, headlights, balloon tires, chrome, and graphics.

Evan Williams, one of Harry Guggenheim's chauffeurs around 1920, performed the duties of a driver. These included car cleaning and maintenance, driving the children to school, taking the maids to the village and church, picking up the mail, waiting for the Guggenheims, and delivering fresh flowers, fruits, and vegetables from the mansion to the city residence.

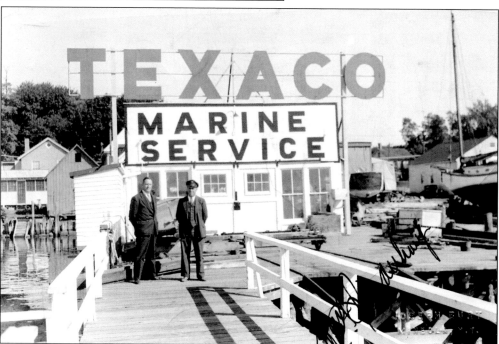

In this work-a-day picture at the A&R Marshall Shipyard, the owners pose in front of the Texaco marine service station that was used to gas up boats on the bay. The low building on the left is the Manhasset Bay Tavern, where the authors suspect another kind of "fill 'er up" took place.

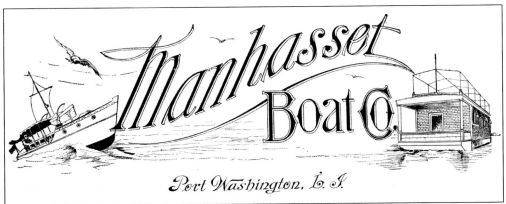

This original letterhead stationery is from the former Manhasset Boat Company, based in Port Washington. Located near the Port Washington Yacht Club, it built, sold, and serviced area boats, including houseboats. Known as builders of quality boats, it made runabout specials with keels and frames of oak. Its watermobiles went up to 15 miles per hour and had a Curtiss toilet and folding basin in the 1930s.

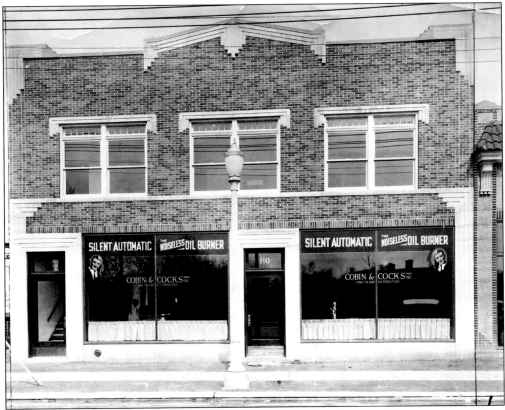

Cobin and Cocks distributed noiseless oil burners from their offices at 110 Main Street in 1926. The burner industry was still in its formative stages, but these Port Washington entrepreneurs were early promoters of the shift from coal to oil. As a local advertisement put it, "Why tend furnace, shovel coal, drag out ashes and put up with dirt, drudgery and the inconvenience of coal when you can have noiseless heat?"

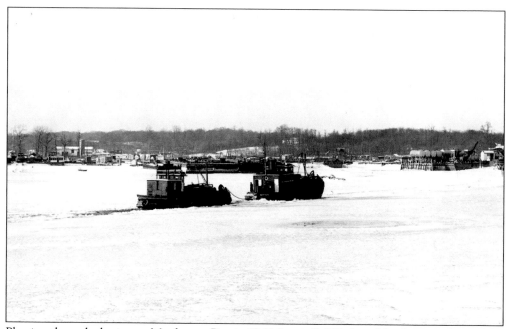

Plowing through the ice on Manhasset Bay in 1947, Lewis Oil Tugboat No. 8 cuts a channel for barges to deliver coal and oil to the storage tanks in the background of this picture. Established by brothers Frank and George Lewis in the early 1900s, Lewis Oil Company supplied Port Washington with coal and wood for over 100 years.

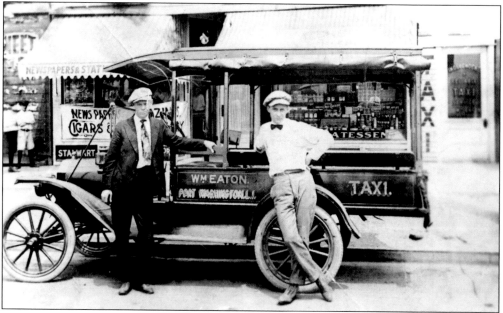

Enterprising taxi drivers wait for customers at the corner of Irma Avenue and Main Street around 1908 near the Port Washington railroad station. At the time, a new invention, the taximeter, had heralded the use of the word *taxi* in referring to automobiles available for short-term hire. Roads in town were still mostly unpaved, and taxi trips had groups of passengers with multiple short-distance destinations.

TRAINS, PLANES, AND AUTOMOBILES

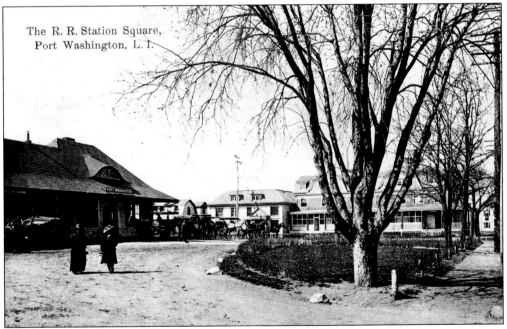

The Long Island Rail Road plaza around 1908 was a place for hacks drawn by horses and tourist lodgings. The Victoria Hotel can be seen with its long enclosed porch. Victoria Hall, adjoining, was the site of lantern slide movies and dancing and theatrical shows. Now demolished to make room for parking, the station plaza is only recognizable by the eyebrow windows and sloped roof of the station itself.

Horses, wagons, and carriages shared Main Street when this picture was taken, around 1900, at the intersection of South Washington Street. Without blacktop paving, the road, one of Port's busiest intersections today, was dusty and muddy and needed to be oiled in the summer. The rail fence and embankment are no longer there, and the Webb homestead in the distance became the site of Port Washington's first high school, the Main Street School.

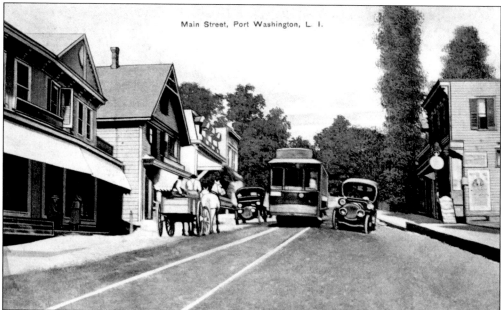

Main Street around 1918 was a magnet for trade and traffic. The relatively new automobile simply joined the traffic stream of horses and wagons, bicycles, and trolleys. Out of necessity, Main Street was widened and more parking areas were created for local shoppers and commuters. This postcard of lower Main Street shows Delvan's ice-cream parlor, Bayles' drugstore, McKee General Store, and the 1907 Telephone Building.

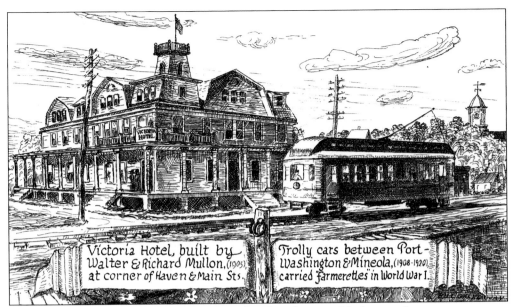

Victoria Hotel, built by Walter & Richard Mullon, (1905), at corner of Haven & Main Sts.

Trolly cars between Port Washington & Mineola, (1908-1920), carried "Farmerettes" in World War I.

The Port Washington trolley and later the railroad made it possible for out-of-towners to come to hotels such as the Victoria Hotel, built in 1905 to accommodate increasing numbers of visitors. Among its amenities were electric power and a bowling alley. The caption by Port Washington artist Bill Galloway refers to "farmerettes" who came to Port Washington by trolley to work on farms during World War I to raise food for export overseas.

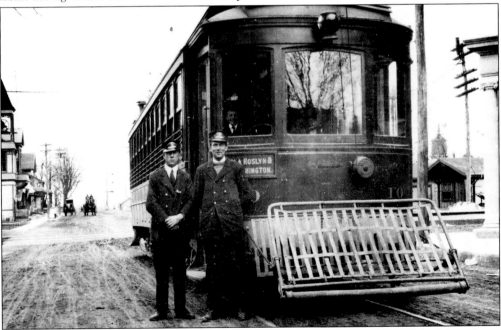

Conductor and motorman Fox and Olsen are seen in 1914 standing in front of the Main Street Port Washington trolley. From 1908 through 1920, it connected the town to the train station and other small villages and towns on Long Island, such as Roslyn and Mineola. Known at the time as the "poor man's automobile," the trolley was inexpensive and convenient, electrically powered by means of overhead wires.

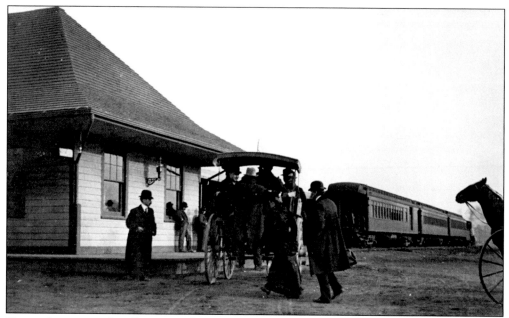

Horses, buggies, and trolleys were the original form of transport to get people to the train on time once the Long Island Rail Road extended its line east from Great Neck in 1898. The land around the station at that time was mostly farmland and rolling hills. By the time of this photograph, around 1905, the station had been expanded and improved from the original structure built in 1899.

The coming of the railroad to Port Washington ushered in an era of increased tourism and prosperity. To get to the station, passengers needed improved roads, better trolley connections, and taxis. The dozen trains that ran daily to and from New York City were described in an 1898 advertisement: "Frequent and efficient, cinder ballast, hard coal engines, express trains, Pintsch gas, good light, no dust, no smoke, no lost time—make a combination unsurpassed."

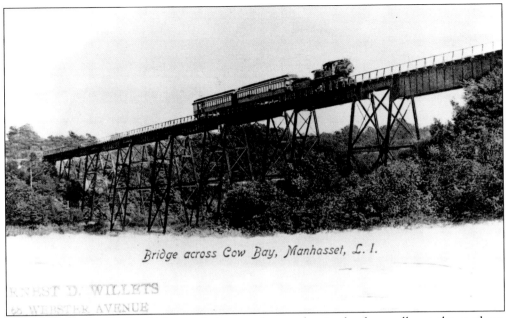

Bridge across Cow Bay, Manhasset, L. I.

This train trestle, 181 feet high, was built over the marshes in the deep valley at the southern end of Manhasset Bay in 1897. It extended Long Island Rail Road service to Port Washington. Built by a subsidiary of Carnegie Steel for about $60,000, the bridge offers a spectacular view of the bay and surrounding shoreline and made it possible for Port to become the commuter town it is today.

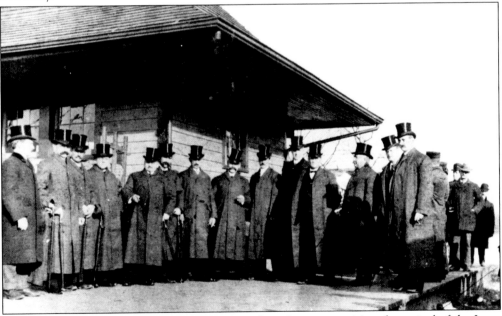

These important-looking gentlemen in coats and top hats are awaiting the arrival of the Long Island Rail Road. They are heading to Washington, D.C., for the inauguration of Pres. Theodore Roosevelt in 1905. For the first time in history, Port Washington was represented at this event, by Jacobs, Lewis, Bieler, Huebner, Hehn, Dickinson, Mitchell, Hults, Mackey, Heffernan, and Carpenter, among others.

Similar to today's rush-hour crush at the Long Island Rail Road station in Port Washington, this 1937 photograph conveys the rapid growth in the town's automobile population and the town's transition from a farming community to a commuter's suburb. As cars became more numerous, faster, and larger, the parking lot grew and businesses sprang up on Haven Avenue.

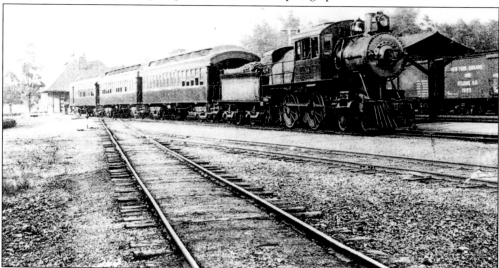

This is a picture of the last steam locomotive to puff out of Port Washington, pulling three wooden passenger cars. With electrification and new trains arriving on October 24, 1913, many bid a fond farewell to smoke, dust, and cinders. But some riders complained of a bumpy and noisy ride and referred to the new electric trains as "cattle cars."

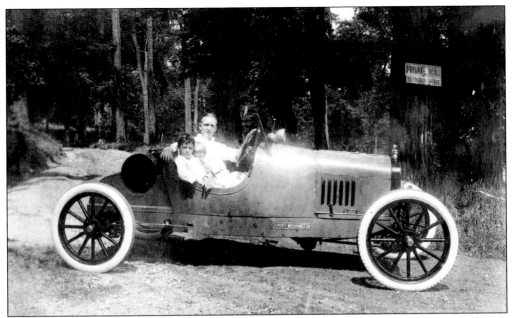

Gerald Rice and his "homemade" car go for a Sunday drive with youngsters Irving and Frank Markland in 1921. The location is Markland's Lane and East Shore Road in Port Washington. American mechanics began to construct their own imitations and adaptations of European models in the years after World War I, using the newly developed aluminum metal in construction to get the look and feel of the open roadster.

As soon as gasoline-powered automobiles began to catch on in the United States in the early 1900s, toy manufacturers started producing miniature versions of cars for children to play with and ride on. Here, near the Mill Pond in Port Washington, Willie Leiber is intent on steering straight, pushing his feet, and honking the horn in his Speedwell toy pedal car in December 1912.

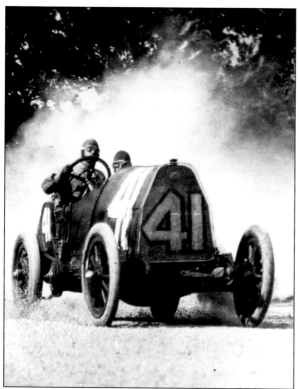

The son of a wealthy Cincinnati publisher, Caleb S. Bragg was a well-known resident of Sands Point and leading figure in automobile racing, motorboating, and aviation. He is seen here in 1910 or so racing his two-seater chain-driven Fiat. Bragg won many trophies in the United States and abroad and, with Victor Kliesrath, invented the booster vacuum brake.

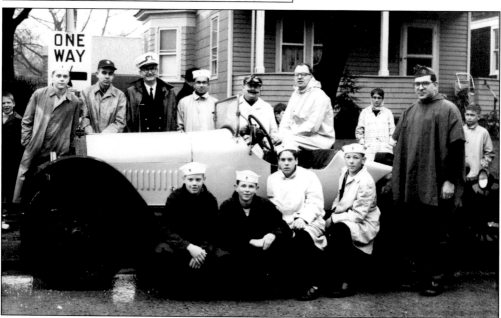

An antique roadster attracts the attention of a group of car aficionados at an antique car rally in Port Washington in 1961. Automobiles representing every year, make, and model were on display by their proud owners. Lions Field, off Sandy Hollow Road on the northern side of town, was the center of all this activity as crowds from all over Long Island showed up for its annual antique car show.

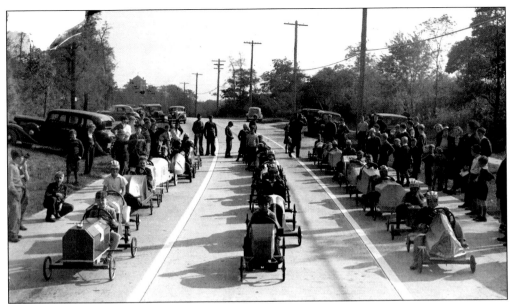

The soap box car derby was sponsored annually by Lyon's Chevrolet on Haven Avenue. In this 1936 competition, 10–12 year olds race toward the IBM Country Club. Huge Malone followed by Terry Cowley are front left, with Bucky Walker and Joseph Caparella behind. Such events were an expression of the spread of the car culture in Port Washington. Malone's car, the *Port Clipper*, had a straight front end with a model clipper ship attached to it.

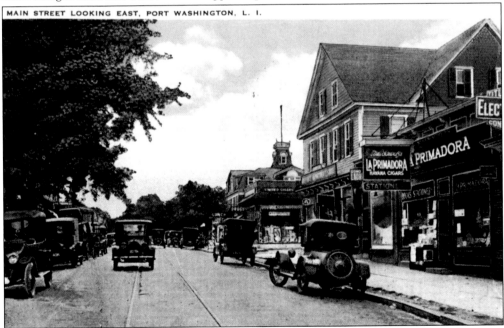

This color postcard image of Main Street, Port Washington, looking east around 1923 illustrates the impact of Henry Ford's famous Model T on this business thoroughfare. Its success peaked that year, when the Model T touring car prices had been reduced to $298, making it affordable for the ordinary wage earner. Remains of the trolley tracks remind one of the once-popular mode of transport well into the 1920s.

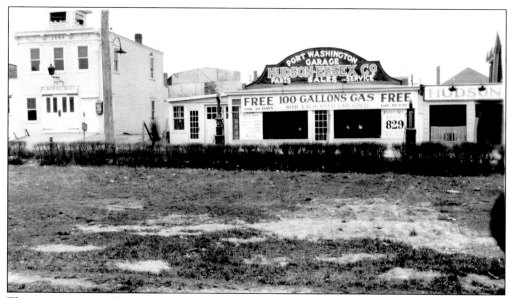

This western view of Haven Avenue is from around 1927. To the left is the original building of the Flower Hill Hose Company. To the right of the firehouse is Port Washington Garage, which sold and serviced Hudson and Essex automobiles, first introduced in 1919. The Essex brand line was one of the first affordable sedans, designed to compete with Ford and Chevrolet. Note the free 100 gallons of gas offered for each used car sold.

This well-worn snapshot depicts Frederick "Sparky" Biddle at the pumps in the 1940s. His gas station and garage were across the street from the railroad station. Legend has it that whenever a car came in with a problem he would say, "Gotta be the spark plug." Sparky was a mechanic and lubrication man. His garage was one of the most popular and well known in town.

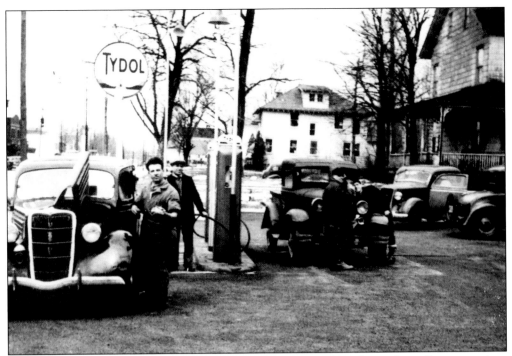

In 1919, New York raised the speed limit for travel from 20 to 30 miles per hour. Service stations began to appear on strategic corners. On Port Washington Boulevard in 1938, these Tydol service station attendants fill the tank of a 1935 Ford V-8 at 10¢ per gallon. Tydols were common from 1938 to 1955, owned by Associated Tide Water Oil Company.

These eight riders in the North Shore Motorcycle Club in 1943 include 16-year-old Charles Davenport, sitting on a 1929 JD motorcycle; Bud Gibson; and Jack Cowley. They are on Harbor and Shore Roads across from the Mill Pond. Motorcycle clubs met at a gas station on Carlton Avenue and Main Street. They had their own social halls and names like the Pagans, the Pharaohs, the Breeds, and the Stone Gypsies.

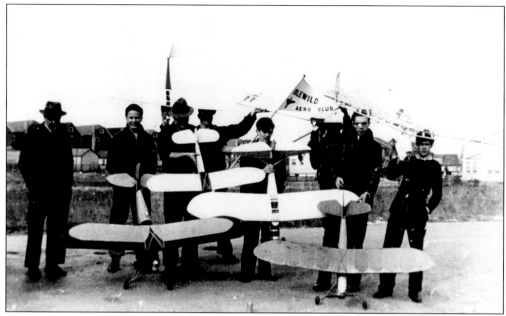

Aero clubs were often the first introduction Port Washington youngsters had to flying. One such club, the Idlewild Gas Model Club, had regular meetings such as this one in November 1937. Members came from all over Long Island and practiced racing as well as model building. As these young men got older, many became amateur pilots or continued in their workshops well into their adult lives.

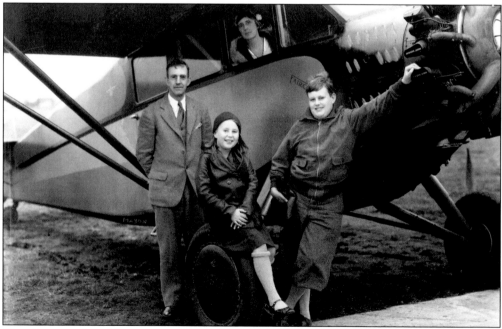

The glamour of wealthy aviators, the support of aviation philanthropists, and the spectacle of low-flying air shows all contributed to a growing enthusiasm for the airplane in Port Washington and all around the country in the 1920s and 1930s. Here Ward Davidson Jr., one of Port Washington's earliest aviation hobbyists, poses with his family and private plane in December 1911.

Famous aviatrix Laura Ingalls was a friend of local resident John O'Neill and flew from Los Angeles to Roosevelt Field in New York in 20 hours, burning seven gallons of gas an hour with a Menasco 125-horsepower engine. In October 1938, Ingalls was photographed standing on the wing of her Ryan monoplane by John Drennan, a well-known aviation photographer.

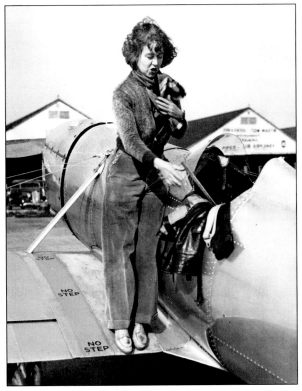

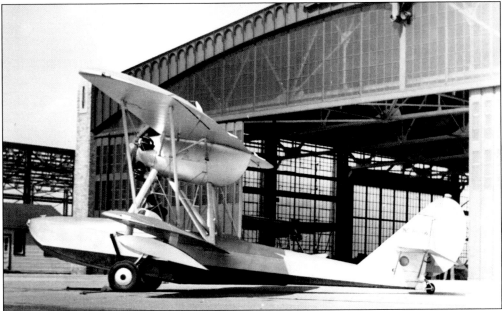

In the first days of flight, when large paved runways were almost nonexistent, the calm, broad waters of Manhasset Bay proved ideal for seaplanes like this Savoia-Marchetti in 1929. Earlier, starting in 1912, Glenn Curtiss tested seaplanes in the bay, and Charles Lindbergh later (1931) flew in and out when he was testing planes for the EDO Aircraft Corporation, named for company founder Earl Dodge Osborn.

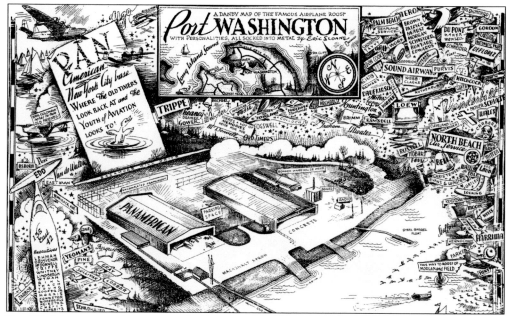

Port Washington was the terminus for Pan American Airlines from 1933 to 1940. This illustrated metal map by artist Eric Sloane paid homage to the famous names in aviation history who participated in the first generation of passenger air travel in the United States during "the golden age of the flying boat." In this 1940 rendering are names such as Harriman, DuPont, Hitchcock, Trippe, and Hearst.

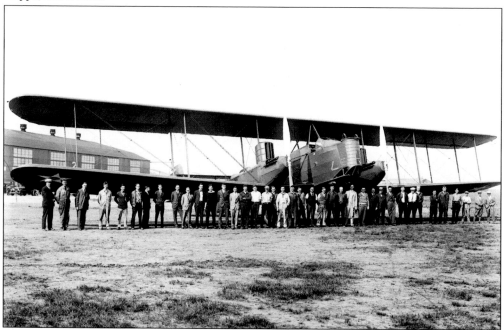

A Curtiss army B-2 Condor Bomber sits in front of its hangar around 1929. Glenn Curtiss opened the Curtiss-Wright flying school in Port Washington shortly before his death in 1930 and was a great influence on the aviation industry locally, inspiring test pilots, building prototypes, and setting the stage for Savoia-Marchetti and Pan Am operations along Manhasset Bay.

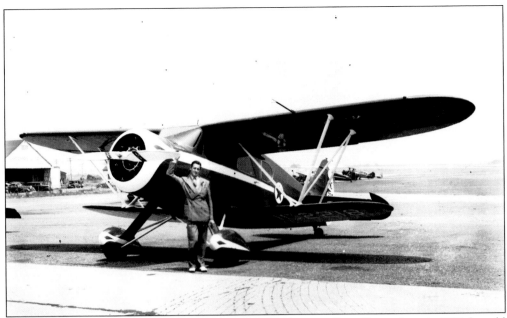

Port Washington resident John O'Neill was a familiar figure in Port. Shown here in 1938, he sold and flew airplanes and worked as an airplane mechanic at Roosevelt Field and American Export Airlines in Port Washington. During World War II, American Export moved to LaGuardia Airport, where O'Neill stayed until he joined Ventura Air Service seaplane base in 1952 as an airport manager. (Courtesy of Drennan Air Services.)

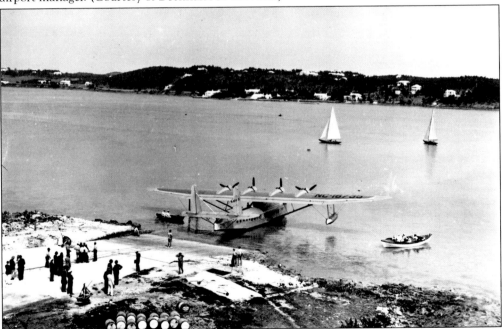

The American Aeronautical Corporation purchased 16 acres of the waterfront area in Manhasset Isle in 1929 in order to build a plant in which to manufacture Savoia-Marchetti seaplanes. This plant was never finished. Pan American acquired a parcel of the island in 1937 and built a ramp and two hangars.

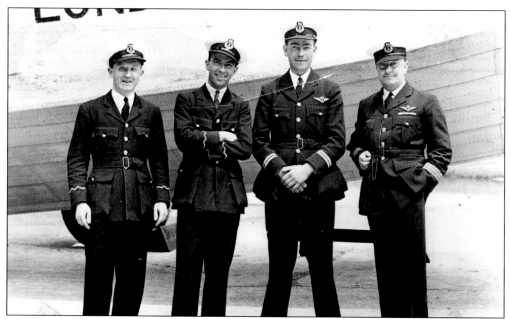

Because the Clippers were intended to compete with ocean liners as an option for luxurious travel, crews of the Clippers were the first in the airline industry to wear naval-style uniforms and adopt a set procession when boarding the aircraft. This is the visiting flight crew of the *Caledonia*, Imperial Airways' version of the "flying boat," which landed in Port Washington around 1937.

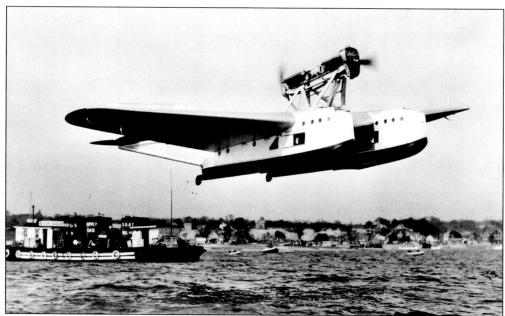

This soaring wonder, the American Aeronautical Corporation type S-55 was also known as the Savoia-Marchetti S-55. Seen here in 1928 in Manhasset Bay, with sandbanks, barges, and motorboats in the distance, this revolutionary aircraft gained fame for Port Washington through its spectacular long-distance flights that took off from Tom's Point. One of the first monoplanes in existence, it was designed with twin hulls and side-by-side pilot's cockpits.

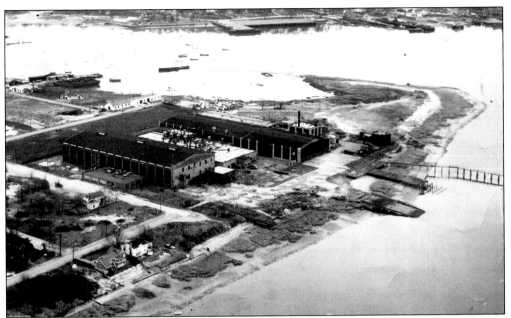

This photograph shows Pan American's airport on Manhasset Isle when it was taken over by Republic Aircraft in 1952. The two large buildings with dark roofs were the Pan American hangars in the 1930s. The ramps and the dock led Clipper passengers to the launches used to reach the airliners. In the 1940s, about 4,000 people worked here on the Grumman "Hell Cat" navy planes.

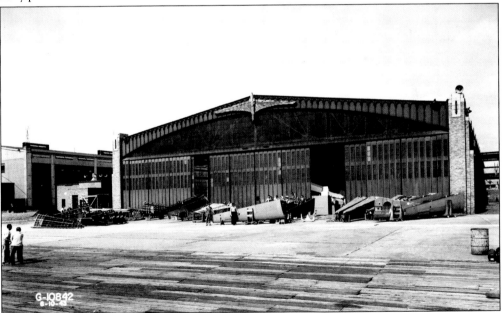

During World War II, Port Washington was a base for the manufacture of warplanes by Grumman and Republic. The passenger terminal, hangar, waiting room, and factory that was once used for flying boats was transformed by assembly lines that made wings for Avenger torpedo bombers in 1943. The insignia of the Savoia-Marchetti Company is still visible on the top of the building, and women riveters are among the workers in front.

CAPT. R. O. D. SULLIVAN & FRIEND
They made the 200th together
(TRANSATLANTIC)

Capt. R. O. D. (Rod) Sullivan and a friend celebrate the Pan Am Clipper's 200th transatlantic flight. Regular weekly passenger and mail service between the United States and Great Britain had begun on June 24, 1937, leaving Port Washington en route to London, England. Captain Sullivan had one of the brightest reputations in transport aviation at the time, having logged in over 14,000 hours with more than 3,200 on Pan American Clippers alone.

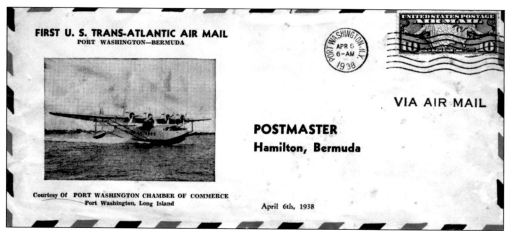

FIRST U. S. TRANS-ATLANTIC AIR MAIL
PORT WASHINGTON—BERMUDA

VIA AIR MAIL

POSTMASTER
Hamilton, Bermuda

Courtesy Of PORT WASHINGTON CHAMBER OF COMMERCE
Port Washington, Long Island

April 6th, 1938

Transatlantic airmail service was inaugurated from Port Washington on May 20, 1939. A month earlier, the first flight to Bermuda carrying passengers and airmail left from Port Washington. This stamped first flight cover was distributed by the Port Washington Chamber of Commerce to commemorate this event on April 6, 1938.

Seven

SCHOOLS AND LIBRARY

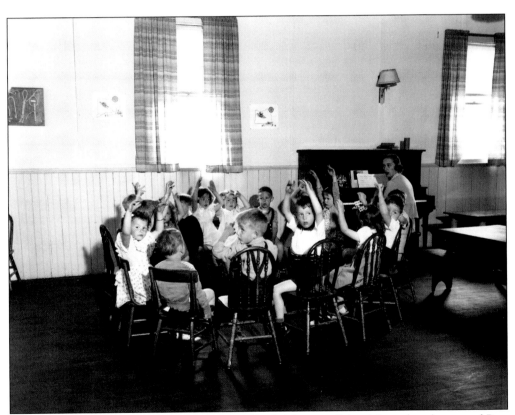

One of several private nursery schools, Mrs. Day's Morning School introduced many of Port Washington's children to music and education in the 1940s. As they grew up, Port's youth could participate in a wide range of theater groups, music clubs, art leagues, and upper-level classes. Today within its five-mile radius, the Port Washington United Free School District No. 5 has five elementary schools, one middle school, and one senior high school. There are five parochial and private schools.

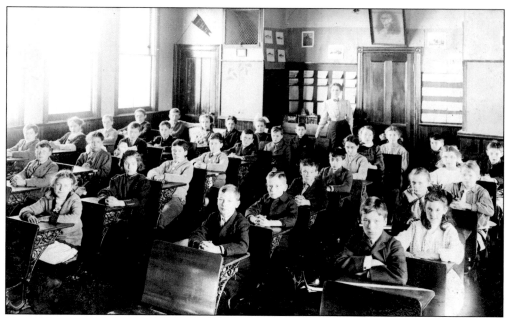

Marie Blanche, teacher, stands at the back of her Flower Hill School fifth-grade class around 1900. Note the portrait of George Washington on the wall. One of Port Washington's public elementary schools, the "old" Flower Hill, was the originator of the present School District No. 4, one of the oldest on Long Island. There were two rooms, and later a library, a room for the principal, and a shed at the back for the students' and teachers' bicycles.

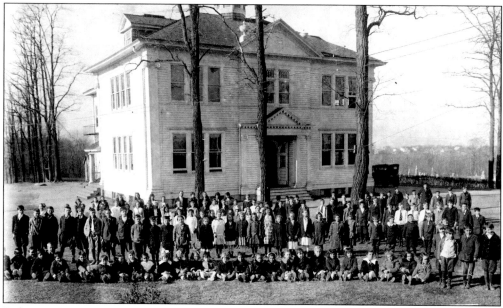

Before 1907, Port Washington was known as Cow Neck. It had two school districts, No. 4 for the Up-Neckers and No. 5 for the Down-Neckers near the Mill Pond. During the winter months, the children were instructed six hours a day, six days a week, 52 weeks a year. The boys cut wood and tended the fireplace while the girls kept the schoolroom neat and clean.

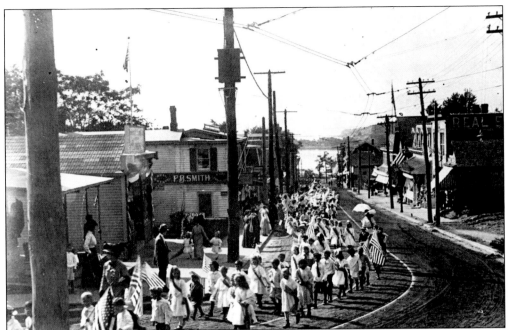

The dedication of the Main Street School was one of the most important gatherings in Port Washington's history. It took place on September 17, 1909, when more than 600 children and their teachers marched up the hill to their new school building on the hill. Out of view in this picture, the Port Washington Band led the retinue.

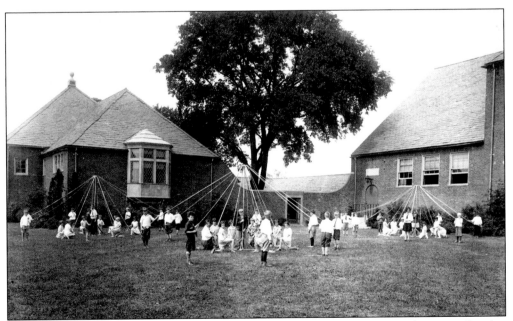

Maypole dances were a common ritual of spring for children in Port Washington. On this occasion at the Flower Hill School on May 27, 1925, the boys danced clockwise while the girls moved counterclockwise, weaving in and out to make patterns with their colorful ribbons. Long hours of rehearsal and choreography practice ensured smooth performances.

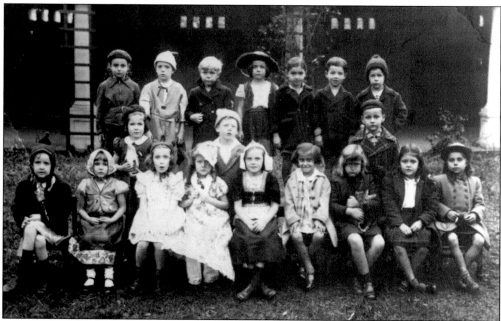

Possibly dressed for Halloween (or *Hallowe'en*, as it was written then) in 1940, this adorable Flower Hill Kindergarten class was led by its teacher, Miss Woodward, who decided to let her students star in this picture of some of the costumes favored at the time. It appears that dressing up was optional. Halloween, as a commonly celebrated American holiday, came into its own in the 1920s.

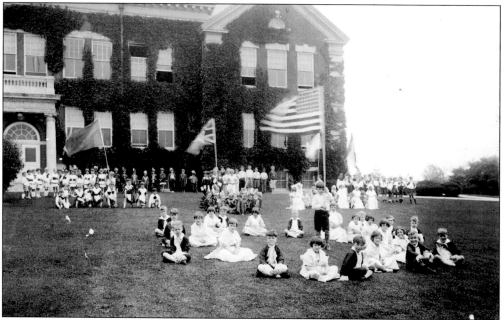

Old-timers will recognize this panorama of "internationals" as they appeared on the front lawn of the Main Street School in 1928. Each group was a school class representing a different country. Notice the British and American flags and the other groups that are included in the wonderful display of (European-based) international amity.

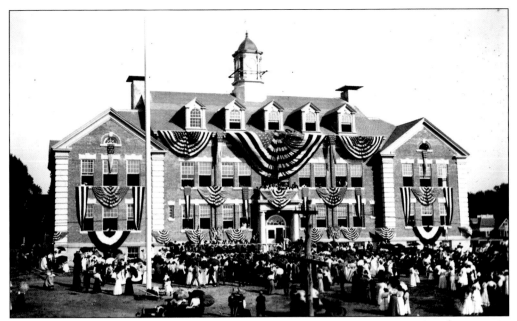

The iconic Main Street School is the most recognizable landmark in Port Washington. In the celebration pictured here, the town came out to witness the dedication of the school on September 17, 1908. With its tall cupola and hilltop location, Main Street School was not only a monument to learning but also a beacon for sailors as they pulled into the harbors along Manhasset Bay.

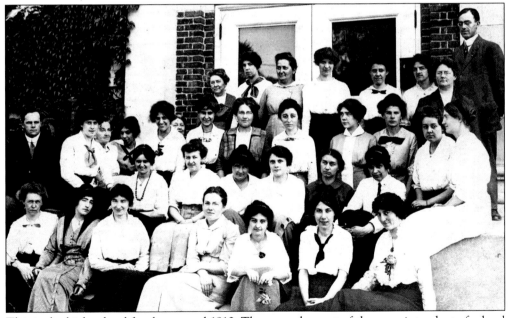

This is the high school faculty around 1910. The annual report of the superintendent of school states that there were 1,200 students enrolled in the school system and 49 teachers in June 1912. Women teachers were cautioned to be above reproach and especially not to take taxicabs after dark. The men in the picture were probably a school principal and superintendent or possibly the coach.

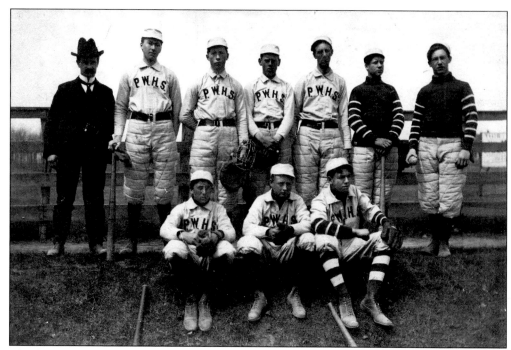

The first Port Washington High baseball team, 1904, was known as the Down Neck team and represented School District No. 5. It played the Up Neck team that represented School District No. 4. Standing, from left to right, are Fred Farmer, umpire; Stephen Smith; John Erickson; T. Wansor; Charles F. "Chip" Dodge; Alfred Bayles; and Thomas Fay. Seated are Martin Smith, Harry Wetmore, and Benny Markland. The battery consisted of Fay and Erickson.

The Port Washington High School track team in 1925 featured runners like Leonard Thorne Cocks (third from left, second row). Coach Carl Seeber is seen in the back in the center. In 1928, the track team dedicated its new Flower Hill Athletic Field with sweeping victories over Great Neck. Port Washington track teams won the team trophy 12 times between 1919 and 1941.

Girls' basketball at Port Washington's junior high school had a different look in 1931. The team's loose trousers, cinched at the knee, were called bloomers, after feminist Amelia Bloomer. The team was coached by Gertrude Nicoll (second row, right), an ex-basketball star at Main Street School in 1925. Encouraged by coach Seeber, she studied at Cortland and returned to Port Washington to be a physical education teacher.

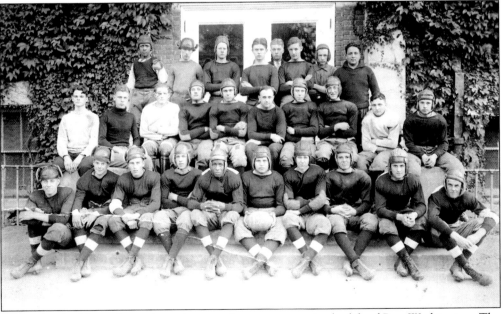

High school athletics have always been an important part in the life of Port Washington. The Fighting Gentlemen football team of 1923 led to a long line of championships and successful coaches. Carl Seeber, for example, started his career in Port Washington and is still fondly remembered for his dedication and advancement to director of athletics for the entire school system's "Blue and Whites."

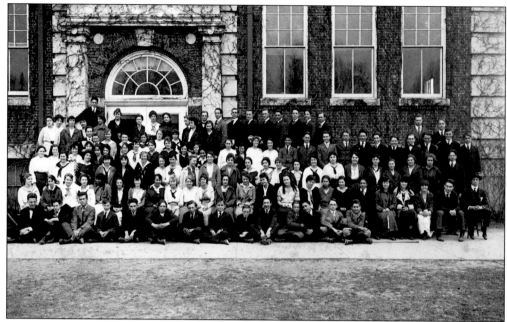

The entire student body of the Port Washington High School in 1917 is shown in this photograph taken in front of the Main Street School building. The picture was lent to Harold and Lillian Seaman by Wilson Dodge and reproduced by Vallie Lewis of Val Gelo's Mason Studio. Many of the old photographs in the Port Washington Public Library collections have been in many hands and passed down through the generations.

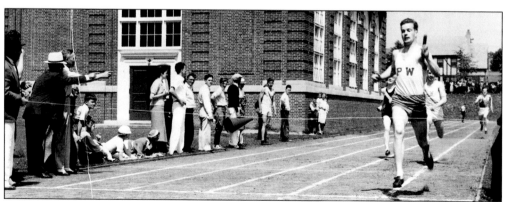

Ray Patten, Port Washington High School sprint star, wins this relay at Glen Cove, about 1934. Coaches Mace and Seeber, were responsible for initiating the concept of "invitationals" in 1919. Throughout Nassau County, these "track and cinder" events each May resulted in growing visibility for Port's young athletes and opportunities for regular hosted sports competitions. The Port Invitation spread the popularity of track throughout the region.

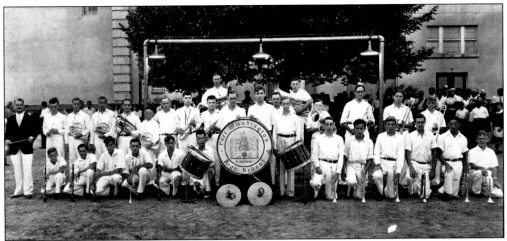

The Port Washington High School Band was formed during the 1929–1930 school year, inspired by resident John Philip Sousa. In this, their first official photograph, the 30 members pose with their director, Paul E. Bergen (far left). Performing at sports events and concerts, Schreiber High School continues to have an award-winning band, which travels abroad and marches in various football bowl parades around the country.

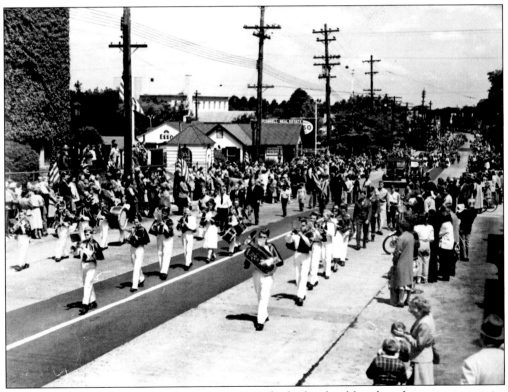

In 1952, as in every year up to the present time, the high school band performance is a major attraction at the annual Memorial Day parade down Main Street. Much of the year is spent preparing for this event, with streets lined with proud relatives and friends. Over time, the uniforms and size of the band have changed, but the instruments remain the same.

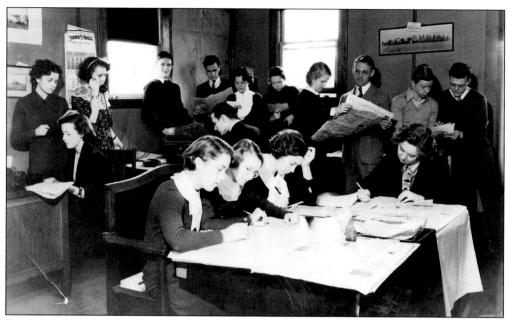

On December 7, 1934, Port Washington news editor Ernie Simon was inspired to invite Schreiber High School journalism students to put out an issue of the community newspaper. William H. Taylor, sports editor of the *Herald Tribune* at the time, wrote to Simon, "I thought the students did a very creditable job with it. Hope they don't all decide to go into the newspaper business now."

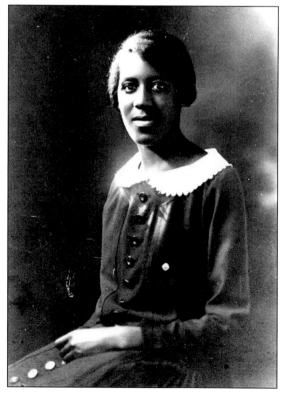

Beatrice Russell was the first African American woman to graduate from the Port Washington High School, in 1926. One of 65 students to graduate, Russell was active in the glee club, the dramatic club, basketball, and girls' softball. Her brother Jerry was a football star. After high school she attended a state teachers college on scholarship and obtained her master's degree in teaching.

In addition to schools, the educational and cultural offerings of the local library has served Port Washington's people for generations. Nurturing and sustaining children's interest in reading has been a fundamental goal of the Port Washington Public Library since its founding in 1892. The tradition of story hours (outdoors in the summer and indoors in a special circle in the winter) continues to this day. The group in this 1940 picture exemplifies ways in which the library is brought into the life of the community at the earliest age.

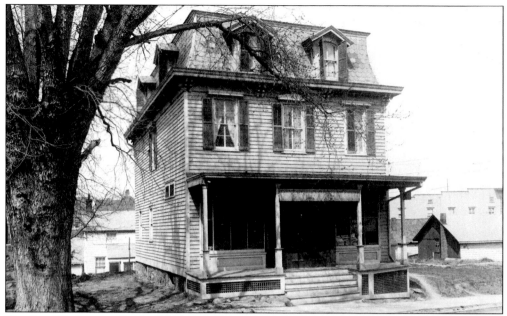

The Port Washington Public Library was founded as a cooperative book club in 1892 by the Port Washington Women's Club, whose original officers included members of the Hicks, Tredwell, Cornwell, Onderdonk, and Mitchell families. They established the library (known then as the Port Washington Free Library) and donated books, which could be checked out by the public at the Burtis Store, shown here on Main Street in 1903.

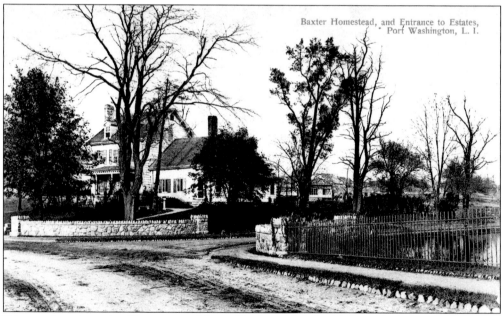

Prior to that time, the library moved from Caroline Hicks's old Cow Neck farmhouse to the front hall of Wilhelmina Mitchell's home, to two parlors in the Baxter home (shown here), which they rented monthly until June 1903. The home is still in existence, on the corner of Shore Drive and Central Road, and is a reminder of the time in 1892 when the population of Port Washington was around 1,000.

In 1926, the library moved to a new location on Belleview Avenue on land purchased from the Tibbetts estate. This photograph shows trustees in 1955. From left to right are (first row) Marie Dunnells, Helen Curtice, and LuEsther Mertz; (second row) Thomas Lapham, Linus Kittredge, Grace Hartell, John Crawley, and Herbert Rose. The portrait of the first librarian, Wilhelmina Mitchell, is above them. In 1933, the library had a circulation of 90,736 books.

This check from Wilhelmina Mitchell (library director, 1892–1926) to Elizabeth Monfort (treasurer) is for interest on a mortgage for the Port Washington Free Library, January 6, 1913. The library depended on the school board to pay them $333 every four months, which was often not received until eight weeks after the due dates. Since Mitchell, there have been only three library directors: Helen Curtice, Edward deSciora, and Nancy Curtin.

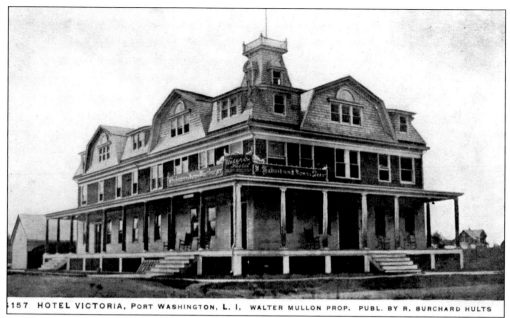

The Victoria Hotel was used for raising funds for the library in the early 1900s. It was near the train station, on Haven Avenue, and had a spacious hall connected to it. The community's good will and generosity yielded $200 from a Grand Parada and Fiesta of song, dance, and drama held there in May 1913. Money was raised for books, supplies, sod for the library lawn, and land on which to build in the future.

411 NASSAU OPEN AIR THEATRE

MONDAY, JUNE 9TH. 1913

Monster Benefit for Children's Department

PORT WASHINGTON FREE LIBRARY

ADMISSION - - 15 CENTS

The Port Washington Public Library always has been and will continue to be a reflection of what its friends in the community have made possible through their leadership and support. As early as 1913, concerned citizens were raising money for the library by organizing and selling tickets to cultural performances and events. Note the price—15¢ for admission to a "monster benefit" for the "Children's Department."

A passion for bookplates, also called ex libris, became widespread in the mid-1920s. Whether art nouveau style, classical, or highly decorated, these impressive plates are from the private libraries of influential Port Washington residents August Belmont and William Bourke Cockran. They were signs of possession and taste, and also guarded against theft.

The reading tables in the old library on Belleview Avenue were well used by Port Washington children. In the seven-year period from 1948 to 1955, the population grew from 16,000 to almost 19,000, and many of the new residents helped swell the ranks of schools and library. In this 1955 photograph is Jean Stooksberry, children's librarian. Seated around the table are (from left to right) Bonnie Santaniello, Alfred Luce, Tom Dunnells, Ted Walter, Carol Santaniello, Mary Romer, Frances Farrell, and Margaret Sweeney.

121

EVERYBODY WORKS FOR THE LIBRARY.

In the May 10, 1913, issue of Port Washington's bimonthly magazine *Plain Talk*, the editor H. K. Landis extolled the virtues of "books and reading for the millions." He reported that the community contributed an inadequate $1.75 per day of support and urged his readers to help build a fine book collection, form clubs, take classes, and learn the value of a library.

Before computerization, circulation staff used pencils with date stamps, counted books by hand, and sent overdue postcards. In this picture from the 1960s, one sees the check-out desk and staff (from left to right) Loretta Brower, Catherine Sandy, Bill Calderero, David Horton, and Helen Beslity. Helen Beslity, then overdues clerk, remembers the "concentrated effort" required for the "archaic system."

Formed in 1960, the Art Advisory Council organizes and mounts exhibits in the library's gallery. Its interior spaces lend themselves to imaginative installations as well as historical and photographic displays. In the photograph above, Emma Galloway presents one of her husband Bill's oil paintings to library director Edward deSciora and Ed Lawrence from the Art Advisory Council, around 1960. The photograph below conveys the sense of excitement and modernity that underlies the less-traditional shows in the gallery. (Photograph by Douglas R. Long.)

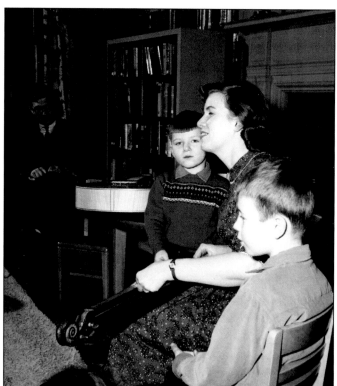

The Music Advisory Council is a volunteer organization within the library that plans programs year-round. Its members scout for musical performers, make recordings, find funding for concerts, attract audiences, and provide a wonderful stage and seven-foot Steinway piano for internationally acclaimed artists. Folk concerts and children's recitals started with Port resident and national treasure Jean Ritchie and her sons John and Peter in the 1960s.

Young Friends of the Library help with a promotional program in 1965 advocating for a new building and bond issue. From left to right, they are Elizabeth Roger, Howard Russman, and Claudia Hartley. Over the years, the Friends of the Library have funded hundreds of projects for the library and worked tirelessly for the benefit of the library. Their annual book and author luncheon draws best-selling authors from around the world.

Library director Ed deSciora (left) unveils a scale model of the proposed new library in 1967. Joining him are, from left to right, Robert Fried, member of the library board; Thomas Lapham, president of the library board; and Benjamin Haller, member of the library board. It was estimated that 5,000 people examined the 95-pound model of the new library. The new building was designed by Curtis and Davis, architects. The most recent addition, designed by Donald and Liisa Sclare, architects, was completed in 2001.

Groundbreaking for the cornerstone of the new Port Washington Public Library took place on October 1, 1967. Pictured are (from left to right) Marie Dunnells (board of trustees), Ellen Crawley (wife of longtime member John Crawley), and LuEsther Mertz (board member). The long-awaited building was centrally located on Main Street on a site of 1.9 acres on a hill overlooking Manhasset Bay. (Photograph by Leo J. Stoecker.)

The Children's Room, in the south wing of the library, is where the youngest library users are introduced to books and learning. It features a sunken story circle and an adjoining area for preschoolers, their books, and now computers. One of the room's early features were the egg chairs, which are no longer used, but were a favorite for singles or groups of children in 1970.

Seen here is a c. 1970 view looking northwest from the new library in cherry blossom season. The total area of the library was 36,500 square feet, with 220 reader seats and room for 240 in the auditorium/meeting space. Book capacity was 150,000 volumes. The outside eastern side of the building is on a natural slope and the finish is alternating glass and architectural concrete in granite tones. Ceilings are exposed structural concrete.

ABOUT THE PORT WASHINGTON PUBLIC LIBRARY

From its beginnings as a cooperative book club in 1892 up until the present time, the Port Washington Public Library has provided access to information and served as a community meeting place, document repository, book center, and cultural arts showcase. Its modern building of concrete and glass, with broad views of Manhasset Bay, opened at its current location on Main Street in 1970 and expanded in 2002. It is a state-of-the-art facility with computer stations, quiet reading rooms, study carrels, a large media area, gallery space, and more. In 1960, Hedley Donovan, then library trustee and editor of *Time* magazine, spoke about what the library meant to him: "For a true community to take shape there must be at least a few institutions that have the whole town, all ages and interests, as their constituency. This great library is just such an institution, perhaps the first Port Washington has ever had. And a tangible beginning toward a definition of what we want Port Washington to mean."

Preserving the past is an important part of the library's function. The Port Washington Public Library is a unique archival repository that has been collecting historic materials from families, institutions, and local organizations for more than 100 years. Formats range from maps, deeds, photographs, and original manuscripts and papers to recordings, video, and artifacts. Since 1983, the library has mounted traveling exhibitions showcasing its holdings and has created Web presentations to increase access to primary sources. It reaches scholars, readers, students, and teachers throughout the world. Oral history and the spoken word add to the depth of the collection. All together, this suburban archive has become increasingly useful in helping people understand their predecessors' roles as creators of and witnesses to historic events. Without the library's commitment to preservation and access, this visual and sound documentation would be lost forever. For more information about the Port Washington Public Library's local history center and archival collections, please contact Elly Shodell, Port Washington Public Library, 1 Library Drive, Port Washington, New York, 11050.

DISCOVER THOUSANDS OF LOCAL HISTORY BOOKS
FEATURING MILLIONS OF VINTAGE IMAGES

Arcadia Publishing, the leading local history publisher in the United States, is committed to making history accessible and meaningful through publishing books that celebrate and preserve the heritage of America's people and places.

Find more books like this at
www.arcadiapublishing.com

Search for your hometown history, your old stomping grounds, and even your favorite sports team.

Consistent with our mission to preserve history on a local level, this book was printed in South Carolina on American-made paper and manufactured entirely in the United States. Products carrying the accredited Forest Stewardship Council (FSC) label are printed on 100 percent FSC-certified paper.